FOLK ART

MUSEUM OF
AMERICAN FOLK ART

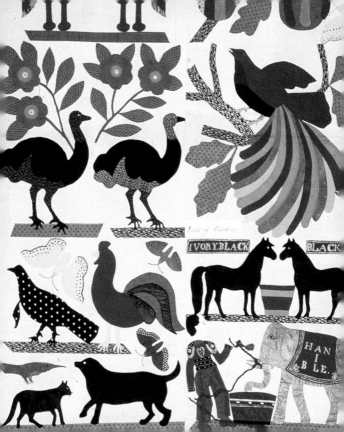

TREASURES OF

Folk Art

MUSEUM OF
AMERICAN FOLK ART

Introduction by Gerard C. Wertkin

Lee Kogan and Barbara Cate

A TINY FOLIO™

Abbeville Press · Publishers

New York · London · Paris

FRONT COVER: Detail, *Girl in Red Dress with Cat and Dog*, p. 22
PAGE 2: Detail, *"Bird of Paradise" Quilt Top*, p. 309
PAGE 5: Detail, *Page from a Sketchbook*, p. 121
BACK COVER: *Weather Vane: Archangel Gabriel*, p. 160
SPINE: *Whirligig*, p. 165

The authors wish to express their appreciation to:
Susan Costello and Celia Fuller of Abbeville Press and to
Janey Fire • Stacy C. Hollander • Ann-Marie Reilly • Judith Steinberg
at the Museum of American Folk Art

EDITOR: Susan Costello
TEXT EDITOR: Alice Gray
DESIGNER: Celia Fuller
PRODUCTION EDITOR: Owen Dugan
PRODUCTION SUPERVISOR: Simone René

Printed and bound in Hong Kong

First Edition

Library of Congress Cataloging-in-Publication Data

Kogan, Lee.
Treasures of folk art : the Museum of American Folk Art / Lee Kogan
and Barbara Cate ; introduction by Gerard C. Wertkin. — 1st ed.
p. cm. — (A Tiny folio)
Includes indexes.
ISBN 1-55859-560-0
1. Folk art—United States—Catalogs. 2. Folk art—New York (N.Y.)—Catalogs.
3. Museum of American Folk Art—Catalogs.
1. Cate, Barbara. II. Museum of American Folk Art. III. Title.
IV. Series: Tiny folios.
NK805.K64 1994
709'.73'0747471—dc20 94-12272
 CIP

Contents

Introduction

Gerard C. Wertkin, *Director*

Of the many distinctive works of art that comprise the permanent collection of the Museum of American Folk Art, among my favorites is a gate in the form of an American flag (pages 224–225). Originally gracing the farm of the Darling family in rural Jefferson County, New York, the gate is believed to have been made in 1876, possibly inspired by the centenary of American independence. An object of utility, a symbol of America, and a work of art, the gate tells us much about the impulses of American folk art. It was also the first object acquired by the museum, the gift of founding trustee Herbert Waide Hemphill, Jr., in 1962. The collection now includes almost 4,000 objects and continues to grow each year.

The museum was founded on June 23, 1961,

when the New York Board of Regents granted a provisional charter to the institution on behalf of the Education Department of the State of New York. Originally called the Museum of Early American Folk Arts, the institution defined its broader purposes when it received its absolute charter in 1965 under its current name. The museum adopted as its mission the fostering of public knowledge and appreciation of American folk art through exhibitions, publications, and educational programming; the institution also undertook the formation of a comprehensive collection to represent the wonderful diversity of this field.

Bert Hemphill's flag gate became symbolic of the museum's first few years, and equally important acquisitions soon followed. In 1963, another founding

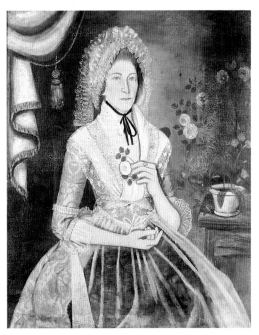

Attributed to Reuben Moulthrop (1763–1814)
Mary Kimberly Thomas Reynolds, c. 1789
Oil on canvas, 45 x 36 in. (114.3 x 91.4 cm)

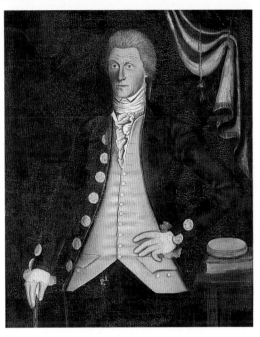

Attributed to Reuben Moulthrop (1763–1814)
Mr. James Blakeslee Reynolds, c. 1789
Oil on canvas, 45 x 36 in. (114.3 x 91.4 cm)

trustee, Adele Earnest, presented a graceful weather vane to the museum, a painted sheet-metal *Archangel Gabriel,* circa 1840 (page 160). Featured as the cover image on the exhibition catalog for the museum's first show, which was held at the Time & Life Building Exhibition Center in October–November 1962, the angel has remained one of the museum's signature pieces. Another weather vane, the monumental, mid-nineteenth-century *St. Tammany* (page 164) was purchased in 1963. Standing almost nine feet high, this sculpture of molded and painted copper may be the largest American weather vane ever created. These early acquisitions were the basis upon which the museum built its reputation for collecting vigorous sculptural forms, a reputation that was considerably enhanced in 1969 by Alastair Martin's gift of 140 outstanding wildfowl decoys (pages 179, 182, 183) and again in 1981 by Dorothy and Leo Rabkin's promised gift of their extraordinary collection of figural sculpture (pages 167, 170).

Because our nation's origins are so diverse, folk art in the United States has always varied greatly in

form and expression. This is one of the fundamental differences between American folk art and the folk expressions of other countries. In Europe, the term "folk art" is usually applied to the traditional household arts of peasant communities; these are art forms that are handed down from generation to generation. America has certainly developed some indigenous artistic traditions, but due to the mobility and ever-changing nature of the population, these conventions have been characterized as much by change as by continuity. Folk art in America is still evolving.

Ironically, the arts of Native Americans were not collected or exhibited within the field of American folk art until recently, because of differing institutional histories and patterns of scholarship. People unfamiliar with the subject would assume that Native American material would predominate; I am pleased that this anomaly is now being addressed. The museum's first major Native American object, a Navajo child's blanket (page 341) was acquired in 1988, the gift of Warner Communications, Inc. in honor of Ralph Lauren.

While folk expressions have never been confined

to a single social or economic stratum of the population, early portraits and needlework indicate that American folk art has often articulated the aspirations of a rising middle class. One of the museum's first major paintings, given by Ann R. Coste in 1970, is a portrait attributed to Isaac Sheffield (c. 1840), which depicts a prosperous woman, possibly a sea captain's wife, clad in a mulberry dress (page 39). During the eighteenth and nineteenth centuries, merchants, farmers, and sea captains alike were eager to have portraits painted of themselves and their families. As itinerant painters roamed the countryside seeking commissions, they developed a unique style unlike that of the academic painters of their day. The nineteenth-century folk portrait style is exemplified by Ammi Phillips's extraordinary painting *Girl in Red Dress with Cat and Dog* (page 22), which was given by an anonymous donor in 1984. When, during the 1920s, American folk art was first studied as a singular and notable aspect of United States cultural history, these artisan painters—who until then had been largely unnoticed—were recognized as the first American folk painters.

Not only painting, but folk sculpture, furniture, decorative objects, and an exceptional gathering of quilts and other textiles each constitute a considerable portion of the museum's collection. In 1981 a number of important works in various media were acquired from Jean and Howard Lipman. Jean Lipman, whose pioneering scholarship in the field is imperative for a serious study of American folk art, is a trustee emerita of the museum. The Lipman purchase included a portrait of Eliza Gordon Brooks by Ruth Whittier Shute and Samuel Addison Shute (page 34); the *Heart and Hand Valentine* (page 133); Paul Siefert's watercolor of the residence of Lemuel Cooper, a Wisconsin farmer (page 66); and a Pennsylvania German *Dower Chest with Mermaid Decoration* (page 204). Other significant acquisitions during the 1980s included woven coverlets from Margo and John Ernst (pages 336, 338); paintings, quilts, and other objects from Cyril I. Nelson; sculpture from David L. Davies, Patricia and Sanford L. Smith, Elizabeth Wecter, and Mr. and Mrs. Francis S. Andrews. More recently, the museum has acquired a large group

of objects by bequest from Robert Bishop, my predecessor as director.

Twentieth-century folk art continues to demonstrate the diversity of the American people and to highlight the contributions of those who have often been excluded from the mainstream cultural life of the nation, including women as well as African-Americans and other ethnic groups. Folk art is by nature multicultural. Through the generosity of donors such as Elizabeth Ross Johnson, Charles and Eugenia Shannon, Alexander Sackton, Mr. and Mrs. Edwin Braman, and Warner Communications, the American artistic mosaic is vividly apparent at the museum; paintings and sculptures by such diverse twentieth-century masters as Howard Finster (page 105), Martin Ramirez (page 76), Bill Traylor (page 149), William Hawkins (page 77), Sister Gertrude Morgan (page 103), and Eddie Arning (page 97) illustrate the broad and vibrant spectrum of contemporary folk art.

This book documents a small selection of these splendid objects and provides an overview of American folk art as represented by the museum's renowned

collections. It is also a celebration of the museum and its more than three decades of public service, which continues to increase as we expand our programs across the globe from our headquarters near Lincoln Center, the heart of New York's cultural life. The museum is currently developing plans for larger facilities, which will allow the exhibition of major portions of the permanent collection for the first time. Meanwhile, the museum's traveling exhibitions continue to be seen throughout the United States and abroad, and its quarterly publication *Folk Art* reaches thousands of members and friends who recognize this art as an essential part of the American heritage. The lively tour of the Museum of American Folk Art presented in this book will surely inspire even greater appreciation for the fascinating lives and works of America's folk artists.

Painting

The museum's comprehensive collection of American folk painting ranges from portraits, landscapes, anecdotal scenes, and still lifes to religious paintings, mourning images in forms including jewelry, and a wide spectrum of works on paper. This compelling variety of materials documents an American culture based on diversity and individual expression, and informed by religion, history, ethnicity, geography, race, gender, and education.

The European tradition of portraiture was brought to the New World by the early settlers. Until the middle of the nineteenth century, when the camera came into popular usage and the daguerreotype replaced the painted image as the most common form of portraiture, artisan limners traveled from town to town. They painted portraits of the growing class of professionals, merchants, and farmers who wished to commemorate their accomplishments and perpetuate

their family memories. Symbols of the patron's trade or profession were often included in the portrait to enliven the work and add decorative elements; portraits of merchants and sea captains frequently contained a ship or telescope (page 35), while educated men were depicted with a book (pages 40, 43), and still others were painted with their families or pets (page 26).

Eighteenth- and nineteenth-century folk painters worked in a variety of mediums, ranging from oil on canvas or board to pencil, watercolor, or pastel on paper. Silhouettes and portrait miniatures often set in lockets were also popular. Twentieth-century examples (pages 47, 53) are more individualized and psychologically revealing—of both the sitter and the artist.

In addition to recording faces for future generations, many self-taught artists have also painted houses (pages 58, 59), farms (page 66), factories (page 61), and ships (page 80), among other subjects. Landscapes were especially popular during the nineteenth century. While some reflected the European romantic tradition of the idealized, dramatic landscape (page 62), most

were straightforward representations of the artisan's or patron's surroundings.

Landscapes by twentieth-century folk artists often take the form of "memory paintings," images of a simpler world that is fast disappearing (pages 67, 69). These nostalgic visions contrast sharply with the hard-edged cityscapes by other contemporary folk painters (pages 76, 77). The landscape of fantasy has become a popular realm for folk artists investigating the resources of their imaginations (pages 78, 79).

Folk painting has also traditionally celebrated everyday life as well as other subject areas. These include genre scenes by twentieth-century painters that range from the highly personalized (page 91) to the idiosyncratic (page 96). Historical subjects are often interpreted as passionate expressions of a social message or political belief; patriotic fervor has inspired numerous depictions of such American heroes as George Washington (pages 114, 115). During the eighteenth and nineteenth centuries, such images were frequently copied from available print sources or other known paintings.

Religion has played a definitive role in the devel-

opment of American folk art. Between 1816 and 1849, a Quaker minister named Edward Hicks painted over sixty versions of *The Peaceable Kingdom* (page 101), a subject based on a prophecy from the book of Isaiah. Biblical scenes such as the Annunciation (page 100) were especially popular among female academy and seminary students during the nineteenth century.

While biblical sources continue to inform twentieth-century religious paintings, contemporary spiritual visions also reflect divine inspiration (pages 104, 111) or intense religious fervor (page 106). Howard Finster's *Delta Painting* (page 105) is at once imaginative and didactic; the artist combines his knowledge of the Bible with a passionate, personal vision. America's religious diversity is noted in the works of Harry Lieberman (page 109) and Malcah Zeldis (page 110), which illustrate Hebrew holy texts and folklore.

German immigrants who settled in Pennsylvania brought with them the fraktur tradition of stylized calligraphic watercolors. These works commemorated rites of spiritual and secular passage such as birth, baptism (page 112), and marriage as well as family records

(page 125), house blessings, valentines, bookplates, scholastic "rewards of merit," and penmanship exercises. Based on medieval illuminated manuscripts, frakturs usually combined colorful depictions of a theme or event with the relevant data or a verse, written in German with elaborate lettering and decorated with such motifs as tulips (page 116) or hearts (pages 117, 118).

Calligraphic drawings proliferated as handwriting became an increasingly important part of school curricula, and during the nineteenth century an ornamental penmanship style flourished as burgeoning commercial interests required a legible script to record transactions. Writing masters and students created beautifully embellished artworks (page 123) characterized by quick, curvilinear strokes.

Still lifes of flowers, fruit, vegetables, and foliage were often done as theorem paintings, or stencil-based works, that were popular as student exercises (page 127). Other still lifes were painted in a freer, more imaginative style (page 131), or created as "tinsel paintings," reverse images painted on glass and backed with crinkled tinfoil to achieve a shimmering effect.

Inspired by earlier needlework examples, mourning pictures were especially fashionable in the first quarter of the nineteenth century; these typically included an epitaph and funerary symbols such as weeping willow, an urn, a tomb, a grieving woman, or other mourners. They were executed in needlework, watercolor on paper (page 138), watercolor combined with needlework (page 136), or as ivory miniatures set in lockets (pages 142, 143).

Cut-paper works by folk artists include valentines (pages 132, 133), paper dolls, and calligraphic drawings that are brightly colored and intricately decorated.

A common theme during the nineteenth century, animals continue to interest twentieth-century folk artists. Whether depicted realistically (page 148) or whimsically (page 151), these engaging figures articulate each artist's unique vocabulary of form.

The plates in this chapter have been organized in the following order: portraits, landscapes and seascapes, genre painting, religious scenes, fraktur and calligraphy, still lifes, cut paper, mourning pictures, jewelry, and animals.

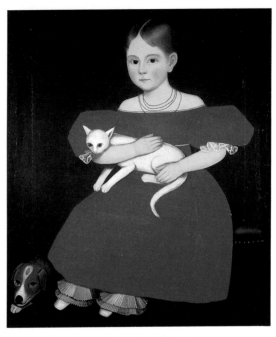

Ammi Phillips (1788–1865)
Girl in Red Dress with Cat and Dog, vicinity of Amenia,
Dutchess County, New York, 1830/35
Oil on canvas, 30 x 25 in. (76.2 x 63.5 cm)

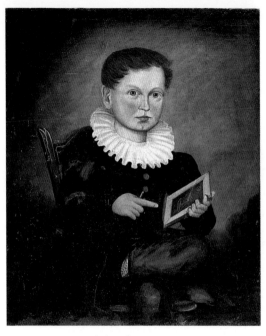

Artist unknown
*Portrait of a Child, probably a member of the
Van Schuyler Family*, Albany, 1820
Oil on canvas, 25¼ x 21¼ in. (64.1 x 53.9 cm)

23

Artist unknown
Portrait of a Child with a Basket,
Mount Vernon, Kennebec County, Maine, 1815
Oil on wood panel, 34 x 18¼ in. (86.4 x 46.4 cm)

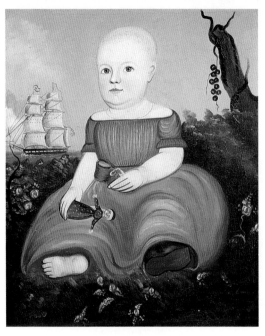

Prior-Hamblin School
Portrait of an Unidentified Child,
probably Massachusetts or Maine, 1835/45
Oil on canvas, 26¾ x 21¾ in. (67.9 x 55.3 cm)

Jacob Maentel (1778–c. 1861)
Portraits of Elizabeth Haak and Michael Haak,
Lebanon, Pennsylvania, 1835/40. Watercolor, ink, and
pencil on paper, each 11¼ x 8 in. (28.6 x 20.3 cm)

Jacob Maentel (1778–c. 1861)
Portraits of Mary Valentine Bucher and Dr. Christian Bucher,
Schaefferstown, Pennsylvania, 1830/35. Watercolor, pencil, and
ink on paper, each 16⅞ x 10½ in. (42.2 x 26.7 cm)

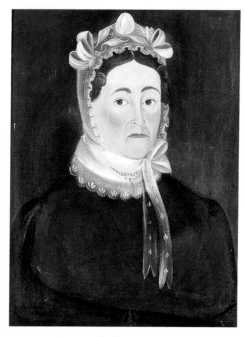

Attributed to Sheldon Peck (1797–1868)
Nancy G. Jackson, Vermont, c. 1820
Oil on wood panel, 21½ x 16¼ in. (54.6 x 41.3 cm)

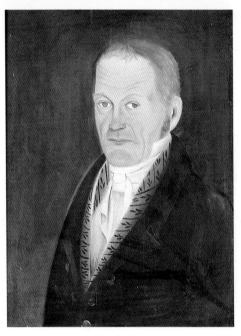

Attributed to Sheldon Peck (1797–1868)
John Jackson, Vermont, c. 1820
Oil on wood panel, 21½ x 16¼ in. (54.6 x 41.3 cm)

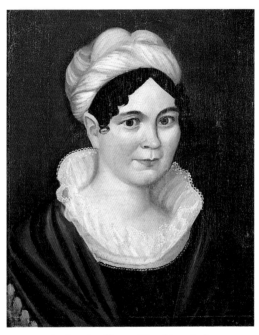

Attributed to Thomas Ware (1803–1827)
Clara Meecham Eddy Churchill, Woodstock, Vermont, 1822/23
Oil on canvas, 30½ x 26½ x 1½ in. (77.5 x 67.3 x 3.8 cm)

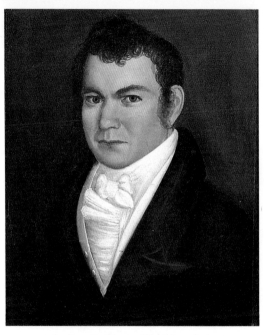

Attributed to Thomas Ware (1803–1827)
Joseph Churchill, Woodstock, Vermont, 1822/23
Oil on canvas, 30½ x 26½ x 1½ in. (77.5 x 67.3 x 3.8 cm)

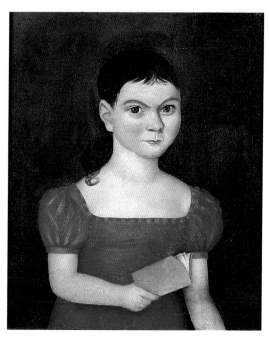

Attributed to Thomas Ware (1803–1827)
Sarah Churchill, Woodstock, Vermont, 1822/23
Oil on canvas, 30½ x 26½ x 1½ in. (77.5 x 67.3 x 3.8 cm)

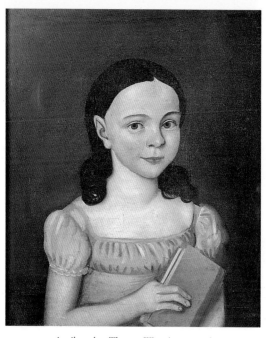

Attributed to Thomas Ware (1803–1827)
Mary Eddy Churchill or Elizabeth Palmer Churchill,
Woodstock, Vermont, 1822/23
Oil on canvas, 30½ x 26½ x 1½ in. (77.5 x 67.3 x 3.8 cm)

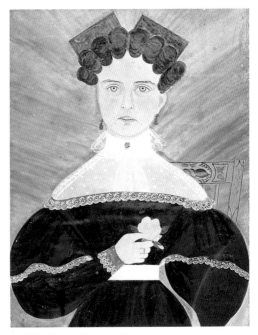

Ruth Whittier Shute (1803–1882) and Dr. Samuel Addison Shute (1803–1836). *Portrait of Eliza Gordon (Mrs. Zophar Willard Brooks),* Peterborough, New Hampshire, c. 1833. Watercolor and gold metallic paint on paper, 24⅝ x 19 in. (62.6 x 48.3 cm)

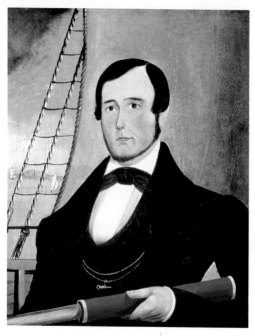

Prior-Hamblin School
Portrait of an Unidentified Sea Captain,
Massachusetts or Maine, 1835/45
Oil on canvas, 27⅛ x 22¼ in. (68.9 x 56.5 cm)

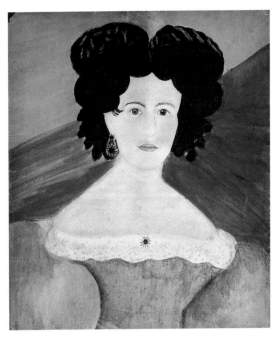

Ruth Whittier Shute (1803–1882)
Portrait of a Woman, possibly Margaret Aflack,
vicinity of Saugus, Massachusetts, c. 1835
Watercolor on paper, 23¼ x 19⅞ in. (59.1 x 50.5 cm)

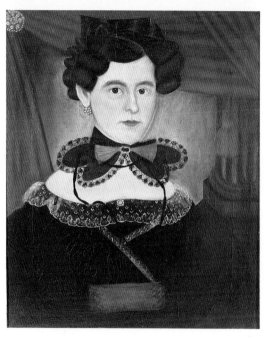

Attributed to Ruth Whittier Shute (1803–1882)
Portrait of a Woman, possibly Caroline Danforth Webster,
possibly Warner, New Hampshire, c. 1832
Oil on canvas, 29 x 25 x 1¼ in. (73.7 x 63.5 x 3.2 cm)

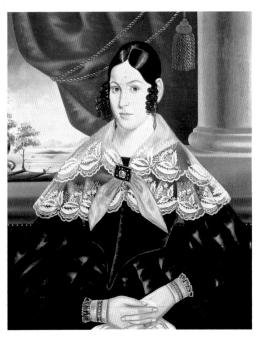

Isaac Sheffield (1807–1845)
Portrait of a Woman in a Mulberry Dress,
probably New London, Connecticut, 1835/40
Oil on canvas, 33⅛ x 27 in. (84.1 x 68.6 cm)

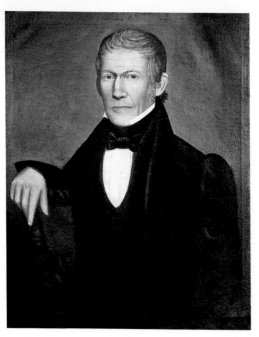

Attributed to Erastus Salisbury Field (1805–1900)
Portrait of a Miller, South Egremont, Massachusetts, c. 1836
Oil on canvas, 30½ x 25¼ in. (77.5 x 64.1 cm)

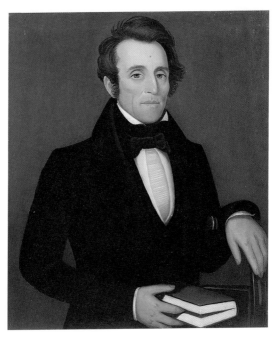

Attributed to Ammi Phillips (1788–1865)
Portrait of a Gentleman in a Black Tie, probably New York,
Connecticut, or Massachusetts, 1838/40
Oil on canvas, 33½ x 28¼ in. (85.1 x 71.8 cm)

Attributed to Ammi Phillips (1788–1865)
Portrait of a Lady in a Gold-colored Dress, probably New York,
Connecticut, or Massachusetts, 1838/40
Oil on canvas, 33½ x 28¼ in. (85.1 x 71.8 cm)

William Matthew Prior (1806–1873)
Portrait of Mrs. Elizabeth Thomas,
East Boston, Massachusetts, c. 1850
Oil on academy board, 17 x 13 in. (43.2 x 33 cm)

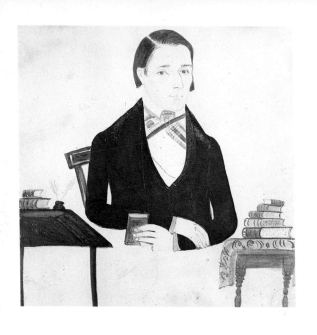

Jane Anthony Davis (1821–1855)
Portrait of a Gentleman Seated Between Two Tables,
probably Connecticut or Rhode Island, c. 1848
Watercolor and pencil on wove paper, 7⅞ x 7⅞ in. (20 x 20 cm) 43

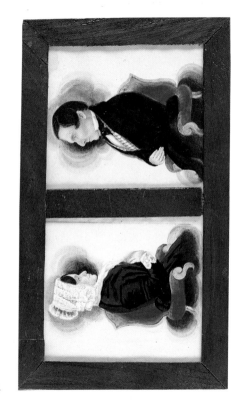

James Sanford Ellsworth (1802/3–1874?)
Lady and Gentleman in Double Frame,
probably Connecticut, 1845/50
Watercolor and pencil on paper, 2⅞ x 2½ in. (7.3 x 6.4 cm)

Artist unknown
Silhouettes, probably New England, c. 1835
Cut paper, watercolor on paper; stamped brass mat, wood frame,
each: 3 5/16 x 2 5/8 x 2 5/8 in. (8.4 x 6.7 x 6.7 cm)

45

Reverend Maceptaw Bogun (b. 1917)
Self-Portrait, New York City, 1972
Oil on canvas, 31 x 25 in. (78.7 x 63.5 cm)

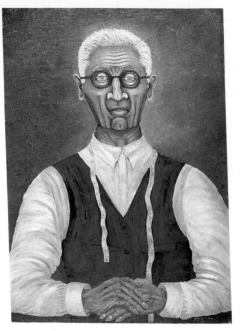

Joseph P. Aulisio (1910–1974)
Portrait of Frank Peters, Stroudsburg, Pennsylvania, 1965
Oil on Masonite, 28 x 20 in. (71.1 x 50.8 cm)

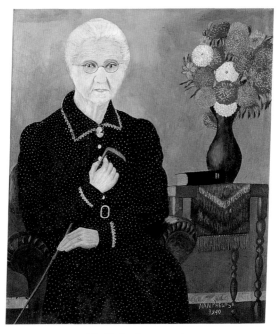

Nan Phelps (1904–1990)
Portrait of Mother, Hamilton, Ohio, 1940
Oil on canvas, 43¼ x 37 in. (109.9 x 93.9 cm)

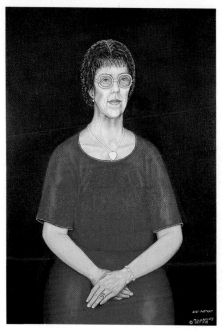

Mattie Lou O'Kelley (b. 1908)
Self-Portrait, Decatur, Georgia, 1978
Oil on canvas, 44 x 31½ in. (111.8 x 80 cm)

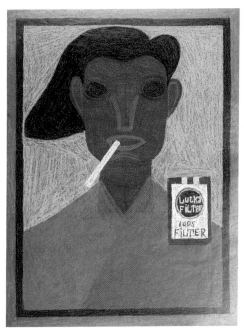

Eddie Arning (1898–1993)
Girl Smoking Lucky Filters, Austin, Texas, 1968
Pencil and crayon on wove paper, 25½ x 19½ in.
(64.8 x 49.5 cm)

Inez Nathanial Walker (1911–1990)
Untitled, New York State, 1974
Pencil, colored pencil on paper, 22 x 14 in. (55.9 x 35.6 cm)

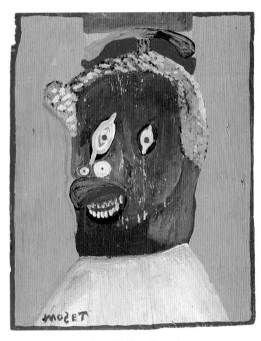

Mose Tolliver (b. 1919)
Self-Portrait, Montgomery, Alabama, c. 1978
House paint on plywood, 20 13/16 x 16 13/16 in. (52.9 x 42.7 cm)

Theodore H. Gordon (b. 1924)
Head of a Man, San Francisco, 1980
Magic marker, pencil, and ballpoint pen on paper,
17 x 14 in. (43.2 x 35.6 cm)

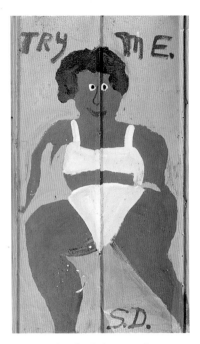

Sam Doyle (1906–1985)
Try Me, St. Helena Island, South Carolina, c. 1983
Enamel house paint on corrugated tin roofing, 43⅛ x 25 x ¾ in.
(109.5 x 63.5 x 1.9 cm)

Sam Doyle (1906–1985)
Portrait of Jackie Robinson, St. Helena Island, South Carolina, c. 1983
Enamel house paint on tin roofing, 56½ x 25¼ x ⅝ in.
(143.5 x 64.1 x 1.6 cm)

Thornton Dial, Sr. (b. 1928)
The Darkness at Night: They All in Fear of What Go On Behind the Darkness, Bessemer, Alabama, 1990. Oil-based paint on plywood with painted wood border, 48 x 96 in. (121.9 x 243.8 cm)

Thornton Dial, Sr. (b. 1928)
Fishing for Love, Bessemer, Alabama, 1990
Watercolor, charcoal, and crayon on paper, 22½ x 30 in.
(57.2 x 76.2 cm)

Artist unknown
The White House, Pennsylvania, c. 1855
Oil on canvas, 12¾ x 17¾ in. (76.2 x 45.1 cm)

Artist unknown
The Pink House, probably New England, c. 1860
Oil on canvas, 16 x 24½ in. (40.6 x 62.2 cm)

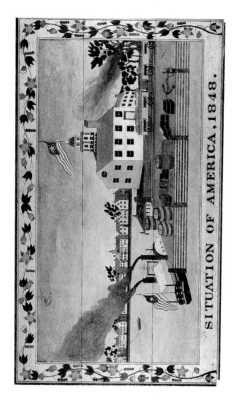

Artist unknown
Situation of America, New York City, 1848
Oil on wood overmantel, 34 x 52 x 1 in. (86.4 x 132.1 x 2.5 cm)

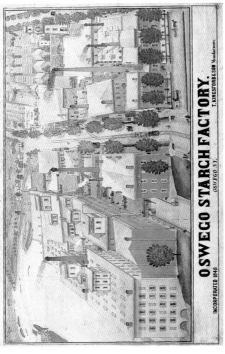

OSWEGO STARCH FACTORY.

(OSWEGO NY.)

INCORPORATED 1848

T. KINGSFORD & SON Manufacturers.

Artist unknown; signed "AJH/77"
Oswego Starch Factory, Oswego, New York, possibly 1877
Watercolor, pen, and ink on wove paper, 36⅛ x 53¼ in.
(91.8 x 135.3 cm)

Artist unknown
Romantic Landscape, vicinity of Sturbridge, Massachusetts, 1830/50
Watercolor on paper, 15⅞ x 20 in. (40.3 x 50.8 cm)

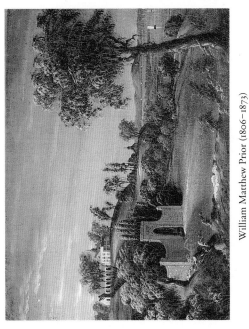

William Matthew Prior (1806–1873)
View of Mt. Vernon and George Washington's Tomb, Boston, c. 1850
Oil on canvas, 19¼ x 25 in. (48.9 x 63.5 cm)

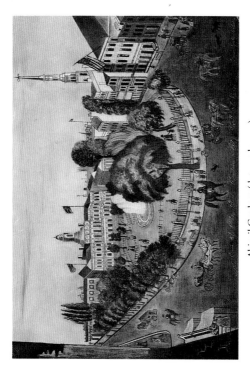

Abigail Gardner (dates unknown)
*View of the Park, Fountain, and City Hall, New York,
New York City*, 1853. Marble dust and charcoal on
Bristol board, 24 x 32 ½ in. (60.9 x 81.3 x 1.3 cm)

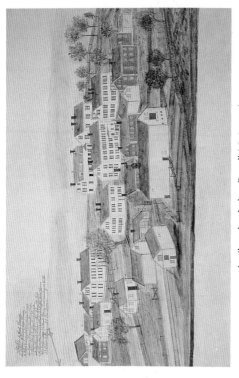

Attributed to Joshua Bussell (1816–1900)
View of the Church Family, Alfred, Maine, c. 1880
Pencil and watercolor on paper, 17¾ x 28 in. (45.1 x 71.1 cm)

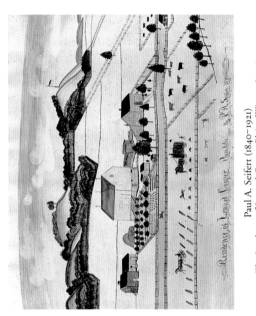

Paul A. Seifert (1840–1921)
The Residence of Lemuel Cooper, Plain, Wisconsin, 1879
Watercolor, oil, and tempera on paper, 21⅞ x 28 in.
(55.6 x 71.1 cm)

Anna Mary Robertson (Grandma) Moses (1860–1961)
Dividing of the Ways, Eagle Bridge, New York, 1947
Oil and tempera on Masonite, 16 x 20 in. (40.6 x 50.8 cm)

Karol Kozlowski (1885–1969)
Cabin in the Mountains, Greenpoint, New York, 1962/68
Oil on canvas, 29½ x 52 in. (74.9 x 132.1 cm)

Mattie Lou O'Kelley (b. 1908)
After the Dry Spell, Georgia, c. 1975
Acrylic on canvas, 24 x 32¼ in. (60.9 x 81.9 cm)

Kathy Jakobsen (b. 1952)
Circus Parade, New York City, 1979
Acrylic on canvas, 24 x 36 in. (60.9 x 91.4 cm)

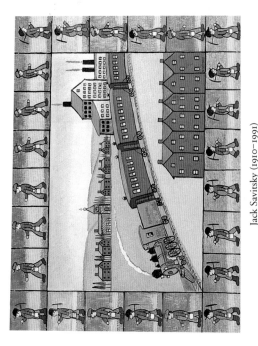

Jack Savitsky (1910–1991)
Train in Coal Town, Lansford, Pennsylvania, c. 1975
Oil on board, 33 x 25 x 1 in. (83.8 x 63.5 x 2.5 cm)

Justin McCarthy (1891–1977)
Jim Thorpe, Weatherly, Pennsylvania, 1968
Oil and tempera on board, 23¾ x 23¾ in. (60.3 x 60.3 cm)

Philo Levi Willey (1887–1980)
Friends of Wildlife II, New Orleans, c. 1975
Oil on canvas, 35¾ x 39 x ⅞ in. (90.8 x 99.1 x 2.2 cm)

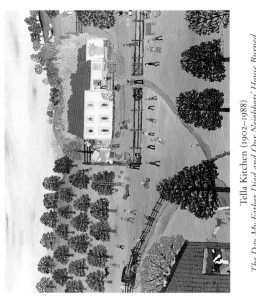

Tella Kitchen (1902–1988)
The Day My Father Died and Our Neighbors' House Burned,
Adelphi, Ohio, 1980
Oil on canvas, 23 x 19½ in. (58.4 x 49.5 cm)

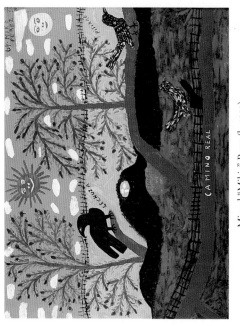

Miguel "Mikie" Perez (b. 1922)
Camino Real, New York City, 1985
Enamel on Masonite, 36 x 48 in. (91.4 x 121.9 cm)

Martin Ramirez (1895–1960)
Train, Auburn, California, 1948/60
76 Pencil and crayon on paper, 52 x 27½ in. (132.1 x 69.9 cm)

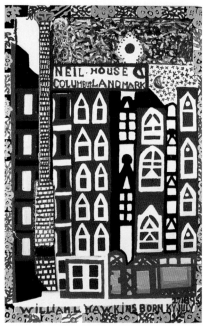

William Hawkins (1895–1990)
Neil House with Chimney, Columbus, Ohio, 1986
Enamel and composition material on Masonite, 72 x 48 in.
(182.9 x 121.9 cm)

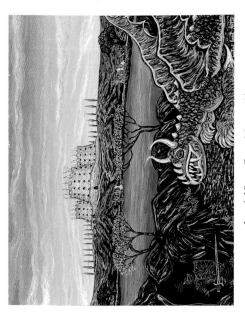

Joseph Victor Gatto (1893–1965)
Dragon, New York City, c. 1943
Oil on canvas, 16 x 19¾ in. (40.6 x 50.2 cm)

Alexander A. Maldonado (1901–1984)
Laguna Azul, San Francisco, 1969
Oil on canvas board, 18 x 24 in. (45.7 x 60.9 cm)

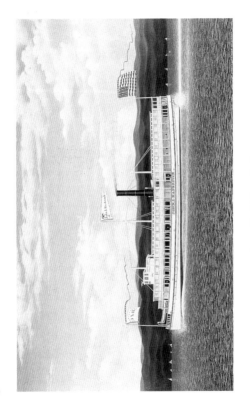

James Bard (1815–1897)
The John L. Hasbrouck, New York City, 1865
Oil on canvas, 35¾ x 55¾ x 1½ in. (90.8 x 141.6 x 3.8 cm)

Artist unknown
Harbor Scene on Cape Cod, Massachusetts, 1890/1900
Oil on canvas, 23 x 31¾ in. (58.4 x 80.6 cm)

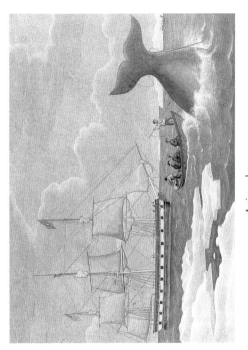

Artist unknown
"Beaver" in Arctic Waters, United States, 1800/25
Watercolor on paper, 18 x 25⅜ in. (45.7 x 63.5 x 1 cm)

Artist unknown
Shooting the Polar Bear in the Arctic,
New England, late 19th century
Oil on canvas, sight 16 x 22 in. (40.6 x 55.9 cm)

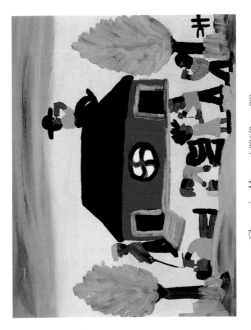

Clementine Hunter (1886/87–1988)
Saturday Night, Melrose Plantation, Nachitoches, Louisiana, c. 1965
Oil on canvas or board, 13½ x 17½ in. (34.3 x 44.5 cm)

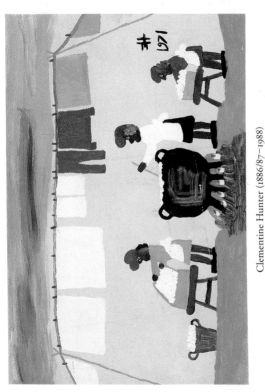

Clementine Hunter (1886/87–1988)
Washing Day, Melrose Plantation, Natchitoches, Louisiana, c. 1971
Acrylic on board, 24 x 16 in. (60.9 x 40.6 cm)

Gustav Klumpp (1902–1980)
The Art Gallery, Brooklyn, c. 1970
Oil on canvas, 25½ x 19½ in. (64.8 x 49.5 cm)

Antonio Esteves (1910–1983)
Life in the Twenties, Brooklyn, 1973
Oil on Masonite, 19⅞ x 23¾ in. (50.5 x 60.3 cm)

Vestie Davis (1903–1978)
Coney Island Boardwalk with Parachute Jump,
New York City, 1941/42
Oil on canvas, 17 x 37 x 1 in. (43.2 x 93.9 x 2.5 cm)

Nan Phelps (1904–1990)
Finishing the Quilt, Hamilton, Ohio, 1980
Oil on canvas, 28½ x 44¼ in. (72.4 x 112.4 cm)

Clementine Hunter (1886/87–1988)
Fishing, Melrose Plantation, Natchitoches, Louisiana, c. 1968
Acrylic on board, 24 x 16 in. (60.9 x 40.6 cm)

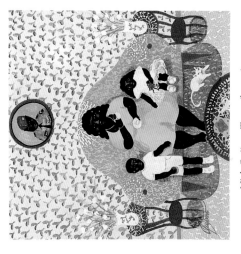

Nick Quijano Torres (b. 1953)
Memories of the Veteran, Old San Juan, Puerto Rico, 1984
Lacquered gouache on paper, 6⅛ x 6¼ in. (15.6 x 15.9 cm)

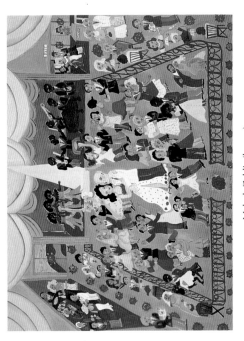

Malcah Zeldis (b. 1931)
Roseland, New York City, 1977
Acrylic on canvas, 30 x 40 in. (76.2 x 101.6 cm)

Nellie Mae Rowe (1900–1982)
Woman Warning Black Dog Not to Eat Too Many Mulberries,
Atlanta, 1978
Wax crayon on wove paper, 19 x 24 in. (48.3 x 60.9 cm)

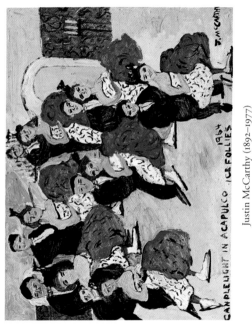

Justin McCarthy (1892–1977)
Candlelight in Acapulco Ice Follies, Weatherly, Pennsylvania, c. 1964
Oil on Masonite, 35¾ x 32 in. (90.8 x 81.3 cm)

Emily Lunde (b. 1914)
Cottage Meeting, 1914, North Dakota, 1976
Oil on board, 18 x 24 in. (45.7 x 60.9 cm)

Bill Traylor (1854–1949)
Figure and Construction with Blue Border, Benton, Alabama, c. 1941
Poster paint on cardboard, 15½ x 8 in. (39.4 x 20.3 cm)

Eddie Arning (1898–1993)
Nine Figures Climbing Trees, Austin, Texas, 1972
Oil pastel and pencil on wove paper, 21½ x 31½ in. (54.6 x 80 cm)

Louis Monza (1897–1984)
The Comic Tragedy, New York City, 1943
Oil on canvas, 54 x 72 in. (137.2 x 182.9 cm)

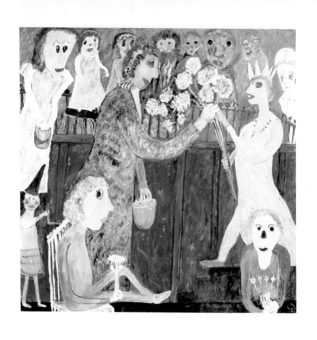

Jon Serl (1894–1993)
The Pregnant Virgin, Lake Elsinore, California, c. 1982
Oil on board, 60¼ x 60¼ in. (153 x 153 cm)

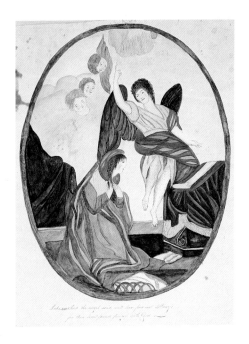

Artist unknown
The Annunciation, possibly New York, 1820/40
Watercolor on paper, 10 x 12¾ in. (25.4 x 32.4 cm)

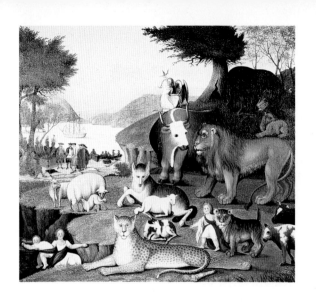

Edward Hicks (1780–1849)
The Peaceable Kingdom, Pennsylvania, 1846
Oil on canvas, 26 x 29⅜ in. (66 x 74.6 cm)

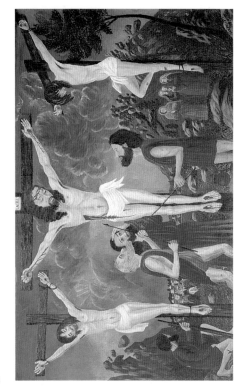

Nan Phelps (1904–1990)
Crucifixion, Hamilton, Ohio, 1940
Oil on canvas, 55¼ x 34 in. (140.3 x 86.4 cm)

Sister Gertrude Morgan (1900–1980)
New Jerusalem, New Orleans, c. 1970
Acrylic and tempera on cardboard, 12 x 19 in. (30.5 x 48.3 cm)

Minnie Evans (1892–1987)
Ark of the Covenant, Wilmington, North Carolina, 1980
Crayon, pencil, and gold paint on card, 13 x 17⅞ in. (33 x 44.1 cm)

Reverend Howard Finster (b. 1916)
Delta Painting, Summerville, Georgia, 1983
Enamel paint on wood panel, decorated wood frame molding,
28⅝ x 45⅛ in. (72.7 x 114.6 cm)

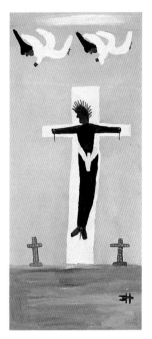

Clementine Hunter (1886/87–1988)
Black Christ on Cross, Melrose Plantation,
Natchitoches, Louisiana, c. 1972
Oil on canvas, 26½ x 11½ in. (66.5 x 29.3 cm)

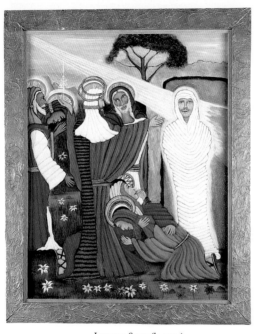

Lorenzo Scott (b. 1934)
Lazarus (Jesus Raising Lazarus from the Dead), Atlanta, c. 1982
Oil on particle board, frame is gilded (automobile repair material)
on yellow pine, 52 x 43 in. (132.1 x 109.2 cm)

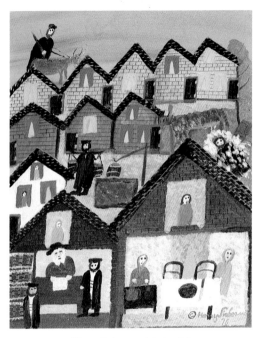

Harry Lieberman (1876–1983)
Two Yeshiva Boys, Great Neck, New York, 1976
Acrylic on canvas, 19¼ x 15 in. (48.9 x 38.1 cm)

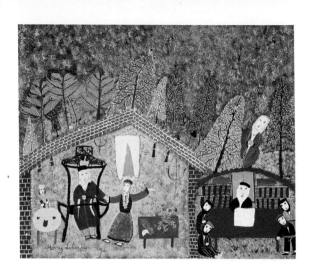

Harry Lieberman (1876–1983)
Whosoever Reports a Thing, Great Neck, New York, c. 1976
Acrylic on canvas, 24 x 30 in. (60.9 x 76.2 cm)

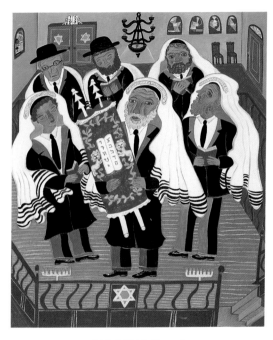

Malcah Zeldis (b. 1931)
In Shul, New York City, 1986
Oil on Masonite, 30½ x 25¼ in. (77.5 x 64.1 cm)

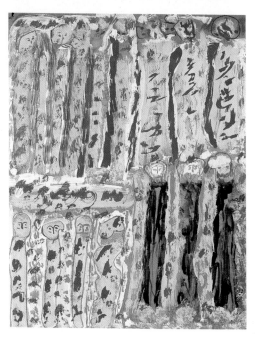

John (J. B.) Murry (1908–1988)
Untitled, Glascock County, Georgia, c. 1984
Tempera and marker on oak tag, 28 x 22 in. (71.1 x 55.9 cm)

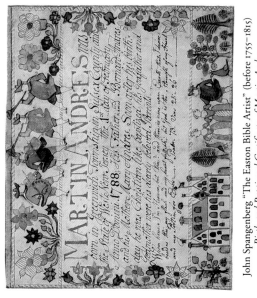

John Spangenberg "The Easton Bible Artist" (before 1755–1815)
Birth and Baptismal Certificate of Martin Andres,
New Jersey or Pennsylvania, 1788
Watercolor and ink on paper, 15½ x 13 in. (39.4 x 33 cm)

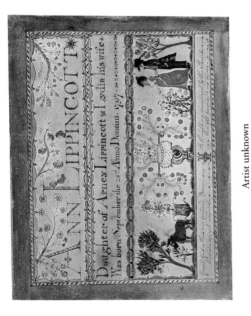

Artist unknown
Birth Certificate of Ann Lippincott, possibly Pennsylvania, c. 1797
Watercolor on paper, 10 x 8 in. (25.4 x 20.3 cm)

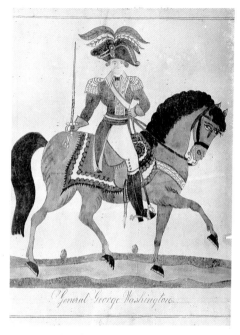

General George Washington

Attributed to Henry Young (1792–1861)
General George Washington on Horseback, Lycoming County,
Pennsylvania, 1825/35. Pen and ink, pencil, and watercolor on
wove paper, 13⅝ x 9¾ in. (34.6 x 24.8 cm)

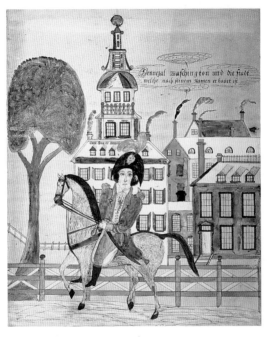

Artist unknown
General Washington, southeastern Pennsylvania, c. 1810
Gouache, watercolor, and ink on paper, 9¾ x 8 in.
(24.8 x 20.3 cm)

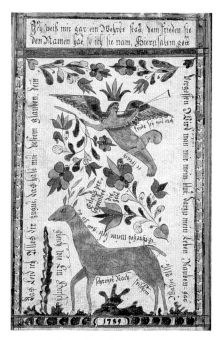

Johann Adam Eyer (1755–1837)
Fraktur, Montgomery County, Pennsylvania, c. 1789
Watercolor on paper, 7½ x 4½ in. (19.1 x 11.4 cm)

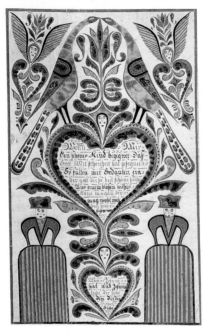

M. Gottschall (dates unknown)
Religious Text Fraktur, southeastern Pennsylvania, c. 1820
Watercolor on paper, 12 x 7½ in. (30.5 x 19.1 cm)

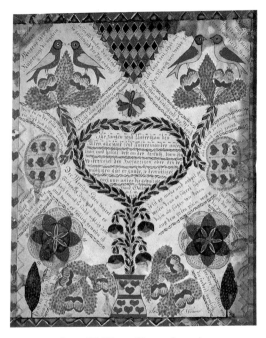

Samuel E. Weaver (dates unknown)
Religious Text Fraktur, southeastern Pennsylvania, c. 1824
Watercolor on paper, 12⅛ x 9½ in. (30.7 x 24.1 cm)

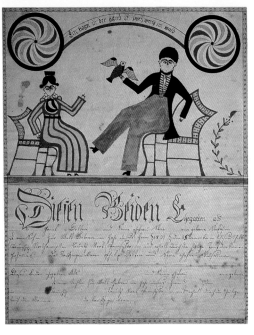

Artist unknown
Birth and Baptismal Fraktur of Johannes Dottern,
Northampton County, Pennsylvania, c. 1831
Watercolor on paper, 15 x 11⅞ in. (38.1 x 30.2 cm)

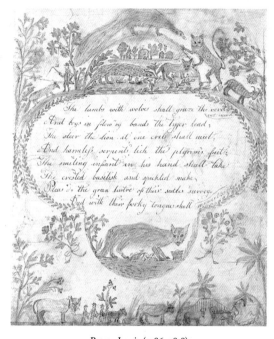

The lambs with wolves shall graze the verd

And boys in silen'ing bands the Tyger lead;

The steer the lion at one crib shall meet;

And harmless serpents lick the pilgrim's feet;

The smiling infant in his hand shall take

The crested basilisk and speckled snake,

Pleas'd the gran lustre of their scales survey,

And with their forky tongues shall

Betsey Lewis (1786–1818)
Page from a Sketchbook: "The Lambs with Wolves,"
Dorchester, Massachusetts, 1801

120 Pen, ink, and watercolor on paper, 7½ x 6¼ in. (19.1 x 15.9 cm)

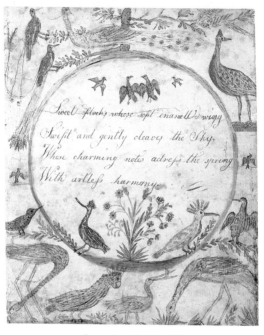

Betsey Lewis (1786–1818)
Page from a Sketchbook: "Sweet Flocks,"
Dorchester, Massachusetts, 1801
Pen and ink on paper, 7⅝ x 6¼ in. (19.3 x 15.9 cm)

Artist unknown
Birth Announcement for Sabraann M. Sittler, Pennsylvania, c. 1833
Pen and ink on wove paper, 7½ x 12¼ in. (19.1 x 31.1 cm)

S. Fagley (dates unknown)
Bald Eagle and Arrows, United States, 1872
Pen and ink on paper, 9¾ x 11 in. (24.8 x 27.9 cm)

Miss Lillian Hamm and Her Students (dates unknown)
Spencerian Birds, United States, 1850/1900
Watercolor on paper, 19½ x 18¼ in. (49.5 x 46.4 cm)

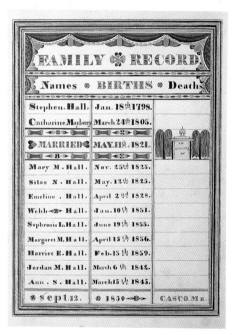

Names	BIRTHS	Deaths
Stephen. Hall.	Jan. 18th 1798.	
Catharine Mayberry	March 24th 1803.	
❦ MARRIED ❧	MAY. 11th 1821.	
Mary M. Hall.	Nov. 25th 1823.	
Silas N. Hall.	May. 12th 1825.	
Emeline . Hall.	April 2nd 1828.	
Webb ❦ Hall.	Jan. 10th 1831.	
Sophronia L. Hall.	June 19th 1833.	
Margaret M. Hall.	April 15th 1836.	
Harriet E. Hall.	Feb. 13th 1839.	
Jordan M. Hall.	March 6th 1842.	
Ann. S. Hall.	March 15th 1845.	
❋ Sept. 12.	❋ 1850 ❦	CASCO. ME.

Attributed to the "Heart and Hand" Artist (dates unknown)
Stephen Hall–Catherine Mayberry Family Record,
Casco, Maine, c. 1850
Watercolor and ink on wove paper, 13½ x 9⅜ in. (34.3 x 23.8 cm)

Artist unknown
Vase of Flowers, New England, 1825/40
Stenciled cotton, 29½ x 18 in. (74.9 x 45.7 cm)

Artist unknown
Grisaille Theorem, New England, 1830/40
Gray wash and pencil on paper, 14½ x 10½ in. (36.8 x 26.7 cm)

Artist unknown
Fruit, Bird, and Butterfly, probably New England, 1825/40
Watercolor on white velvet, 15⅜ x 18¾ in. (39.1 x 47.6 cm)

Artist unknown
Tray of Fruit, probably New England, 1830/50
Watercolor on velvet, 16½ x 23 x 1½ in. (41.9 x 58.4 x 3.8 cm)

Artist unknown
Tinsel Painting, United States, c. 1860
Reverse painting on glass, foil, 14⅞ x 12⅞ in. (37.8 x 32.7 cm)

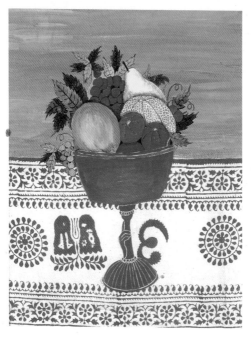

Sophy Regensburg (1885–1974)
Red Collage, New York City, c. 1965
Cloth, painted board, and paper, 22¾ x 18¾ x 1½ in.
(57.8 x 47.6 x 3.8 cm)

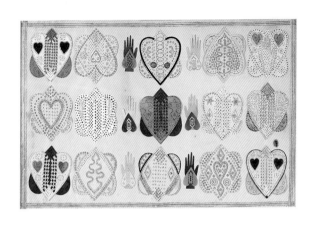

Artist unknown
Valentine, possibly New England, c. 1820
Cut paper, watercolor, and gilt paper strips,
11½ x 16 in. (29.2 x 40.6 cm)

Artist unknown
Heart and Hand Valentine, possibly Connecticut, 1840/60
Cut paper, varnish, ink, 14 x 12 in. (35.6 x 30.5 cm)

Joseph G. Heurs (dates unknown)
Papercut: Fraternal Symbols of the American Protective Association,
probably Pennsylvania, 1919

Paper, 28½ x 28½ in. (72.4 x 72.4 cm)

Joseph G. Heurs (dates unknown)
Papercut: Odd Fellows Symbols, probably Pennsylvania, 1919
Paper, 28½ x 28½ in. (72.4 x 72.4 cm)

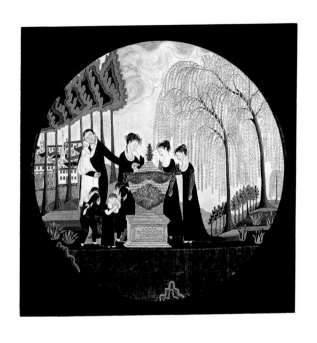

Probably Lovice Collins (dates unknown)
Mourning Picture for Mrs. Ebenezer Collins, South Hadley,
Massachusetts, 1807. Watercolor, silk and metalic chenille thread
on silk, pencil on paper label, 17 in. (48.2 cm) diameter

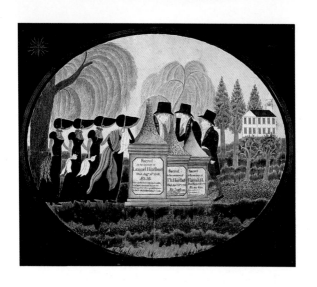

Elizabeth Hurlburt (dates unknown)
Hurlburt Family Memorial, Connecticut, c. 1808
Watercolor on paper, 16½ x 20¼ in. (41.9 x 51.4 cm)

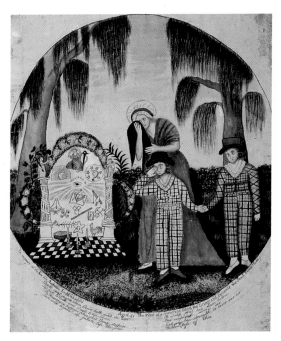

Eunice Pinney (1770–1849)
Masonic Memorial Picture for Reverend Ambrose Todd, Windsor or
Simsbury, Connecticut, 1809. Watercolor on laid paper,
pen and ink inscription, 14 x 11⅞ in. (35.6 x 30.2 cm)

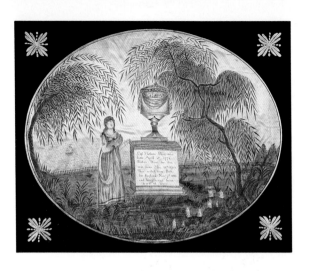

Attributed to Jane Otis Prior (dates unknown)
Memorial for Captain Matthew Prior and his Son Barker Prior,
Bath, Maine, c. 1815
Watercolor on silk, 17½ x 21¼ x 1½ in. (44.5 x 53.9 x 3.8 cm) 139

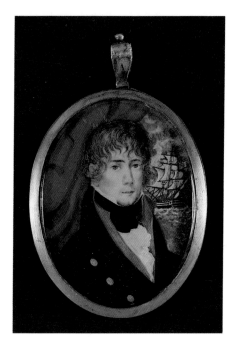

Attributed to Isaac Sheffield (1807–1845)
Portrait of a Sea Captain,
probably New London, Connecticut, 1835/40
Oil on ivory, 2¼ x 1¾ in. (5.7 x 4.5 cm) oval

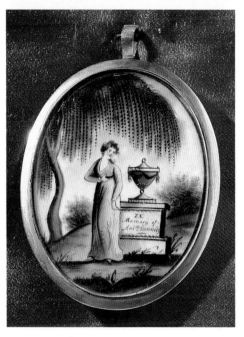

Attributed to Samuel Folwell (1764–1813)
Woman and Urn, Philadelphia, 1793/1813
Watercolor on ivory, gold bezel, human hair, 2½ x 1¾ in.
(6.4 x 4.5 cm) oval

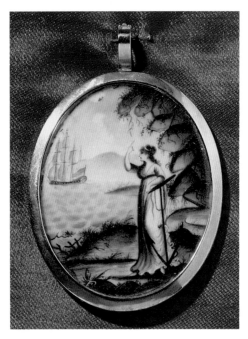

Attributed to Samuel Folwell (1764–1813)
Woman and Ship, Philadelphia, 1793/1813
Watercolor on ivory, gold bezel, human hair, 2½ x 1¾ in.
(6.4 x 4.5 cm) oval

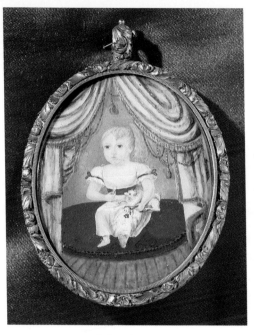

Artist unknown
Portrait of a Child on Cushion, New England, 1825/40
Oil on ivory, human hair, 2¾ x 2⅛ in. (6.9 x 5.4 cm) oval

Artist unknown
Political Pin, New England, 1820/30
Watercolor on ivory, pen and ink inscription,
⅝ x ¾ in. (1.6 x 1.9 cm)

Artist unknown
Silver Watch Chain with Mourning Picture,
Europe or United States, 1825/40
Watercolor on horn, silver, 1 x 1¼ in. (2.5 x 3.2 cm)

Artist unknown
Miniature Pin: Soldiers, United States, 1830/40
Watercolor on ivory, 1¼ x 1 in. (3.2 x 2.5 cm)

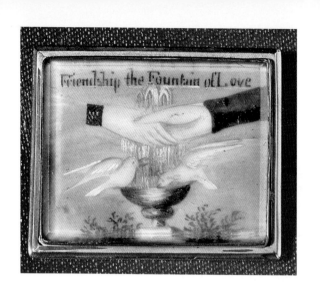

Artist unknown
Friendship Pin (Clasped Hands), United States, c. 1830
Watercolor on ivory, ⅞ x 1⅛ in. (2.2 x 2.9 cm)

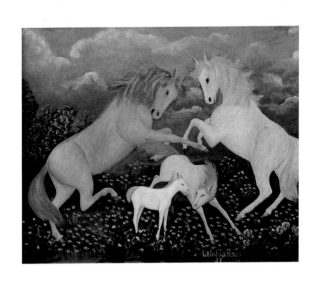

Lawrence Lebduska (1894–1966)
Prancing Horses, New York City, 1937
Oil on canvas, 16 x 20 in. (40.6 x 50.8 cm)

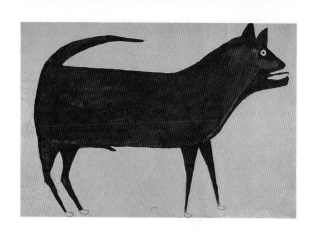

Bill Traylor (1854–1949)
Dog, Montgomery, Alabama, 1939/42
Pencil, crayon, and gouache on paper, 18¼ x 26½ in.
(46.4 x 67.3 cm)

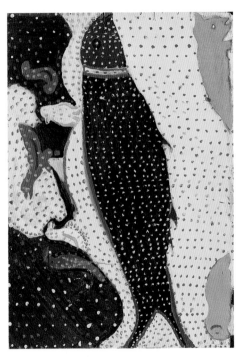

Nellie Mae Rowe (1900–1982)
Black Fish, Vinings, Georgia, 1981
Acrylic on wood, 16½ x 37 in. (41.9 x 93.9 cm)

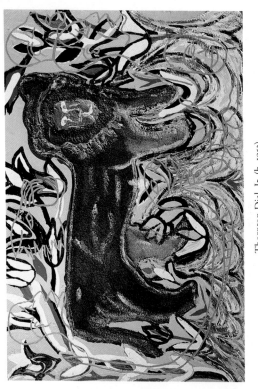

Thornton Dial, Jr. (b. 1953)
King of Africa, Bessemer, Alabama, 1989
Carpet, enamel on incised wood, 48 x 72 in. (121.9 x 182.9 cm)

Sculpture and Three-Dimensional Objects

Traditionally, most folk sculptures combine creative form with useful function, as seen in the weather vanes and whirligigs, trade signs, bird and fish decoys, furniture, boxes and baskets, and decorative domestic objects. A smaller segment of this group includes people, animal figures, and whimsies representing purely artistic expression. Both definitive and encyclopedic, the museum's folk sculpture collection encompasses practical and aesthetic works that depict both utilitarian and whimsical designs.

Silhouetted against the sky and propelled by fickle winds stands America's loftiest folk art—the weather vane. Vanes have been fashioned into everything from birds, fish, and other animals, to people, trains, and an assortment of other shapes. Among the most beloved of weather vanes are the angels designed to spread their wings and blow their trumpets over

church steeples (page 160), and vanes in the form of running horses, which were especially popular during the nineteenth century (page 159).

Whirligigs are wind toys that were stuck in the ground or mounted on a fence. Often crudely made, their inferior workmanship was masked by bright paint. While the earliest examples are simple figures (page 166), later designs are more complex and involve generating a series of interrelated actions, as in *Uncle Sam Riding a Bicycle* (page 168).

Trade signs are perhaps America's oldest and most popular form of outdoor advertising. During colonial days, carved wooden figures and flat painted and lettered signs provided ready identification of the goods or services offered within. The best shop signs and figures were eventually standardized, such as the cigar store Indians (page 174) that were displayed in front of countless tobacconists' stores. Today the large, wooden, and often gaudy and inauthentic Indian shop figure—complete with fringed costume, tobacco belt, blanket, and boots—is truly synonymous with Americana.

Form and function were also united in bird and

fish decoys, which have evolved from tools of the hunter's and fisherman's trade into highly prized works of art. These wooden figures of mallards, pintails, drakes, geese, shorebirds, and other wildfowl were hand carved and, later, factory produced; "real" feathers and other outstanding markings were usually painted on by hand. While most decoys, for example the *Pintail Drake* (page 181), were made to float on the water's surface, shorebirds such as the tiny *Black-Bellied Plover* (page 178) were mounted on sticks in the sand and the colorful fish decoys were dangled into wintry waters through a hole cut in the ice.

American furniture makers generally copied older European styles, though often using less expensive woods such as pine. Folk artists painted faux finishes to approximate the grains of fancier woods; they used a variety of implements—cork, sponges, combs, rags, and feathers—to achieve such impressive effects as the "paw-print" design on the *Tall Case Clock* (page 206). The mock grains and medallions on the *Federal Sideboard Table* (page 196) imitate nineteenth-century high style. Folk furniture designs frequently reflected

the community's ethnic origins, as in the Pennsylvania *Chest of Drawers* (page 201), which is decorated with birds, flowers, and geometric patterns reminiscent of German models.

The Shakers created some of America's finest folk furniture; much of their carefully crafted, practical work is now collected as art. They created their furniture with "hands to work and hearts to God," as exemplified by their celebrated rocking chairs (pages 190, 191).

Boxes and baskets were made of a variety of shapes and materials. Delicately painted boxes were fashioned from wood (page 215) and tin, which became very popular during the nineteenth century. The art of basket weaving was used to address a vast range of purposes—for example, a feed bag (page 222), an *Eel Basket* (page 223), and a *Spool Stand* (page 236).

The impulse to embellish even the most mundane objects has produced some of America's most memorable folk art. The 1876 *Flag Gate* (pages 224–225) by an unknown artist is now an icon of American art and the *Cat Bootscraper* (page 239) is a wonderfully

ingenious symbol of domesticity. Decorated stoneware, redware, and other pottery (pages 228, 235) still abound today.

Sculpture made exclusively for display was rare during the eighteenth and nineteenth centuries. The *Phrenological Head* (page 240) illustrates the nineteenth-century belief that a person's character could be ascertained by studying the shape of the head; sections of the wooden skull are painted to correspond to thirty-seven different faculties. More common were chalkware sculptures of celebrated figures such as George Washington (page 243). Later, fanciful chalkware animals (page 269) became extremely popular.

Sculpture has become more daring and inventive during the twentieth century as folk artists increasingly began to create objects without any real utilitarian purpose. The *Pair of Bird Trees* (page 286) is a charming and whimsical example of art done for its own sake. Even the brightly painted carousel horses (pages 272, 273) are more decorative than functional.

Religious faith has inspired many folk sculptors, including a Kentucky artist who, after having a vision

of a flood, carved an eight-foot crucifix for the bow of an ark (page 256). A Louisiana artist fashioned a gleaming crucifix of tin (page 257). Religious figures carved in wood have been a tradition in the Southwest, where *santeros* have long crafted figures of saints. This art form has been creatively adapted by twentieth-century sculptor Felipe Archuleta, who carved and painted a variety of vibrant, expressive animals; his work has inspired a whole new style of folk sculpture.

The multi-faceted folk tradition extends to such whimsical items as a *Man's Top Hat and Eyeglasses* (page 284), the *Carved Compote* (page 289), and a *Sunburst* (page 288). As with even the most functional objects, each of these colorful, striking works illustrates curator Holger Cahill's 1931 description of the essence of folk art: "It goes straight to the fundamentals of art— rhythm, design, balance, proportion, which the folk artist feels instinctively."

The plates in this chapter appear as follows: weather vanes and whirligigs, trade signs, bird and fish decoys, furniture, boxes and baskets, household objects, figures of people and animals, and dolls and whimsies.

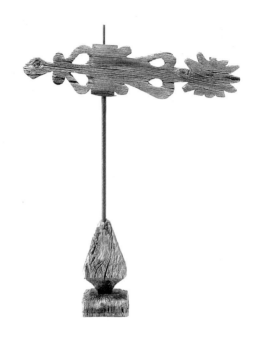

Artist unknown
Weather Vane: Arrow Banneret, New England, late 18th century
Wood, 21 x 28½ x 5 in. (53.3 x 72.4 x 12.7 cm)

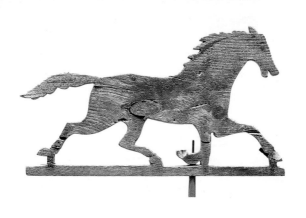

Artist unknown
Weather Vane: Racehorse Dexter, Maine, 1860/1900
Wood, 21 x 28½ x 5 in. (53.3 x 72.4 x 12.7 cm)

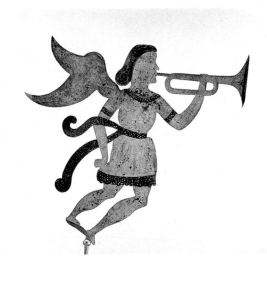

Artist unknown
Weather Vane: Archangel Gabriel, United States, c. 1840
Painted sheet metal, 35 x 32½ x 1¼ in. (88.9 x 82.6 x 3.2 cm)

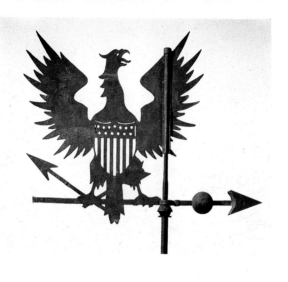

Artist unknown
Weather Vane: Eagle with Shield, Massachusetts, 1800/10
Cast bronze, 36 x 43½ x 4 in. (91.4 x 110.5 x 10.2 cm)

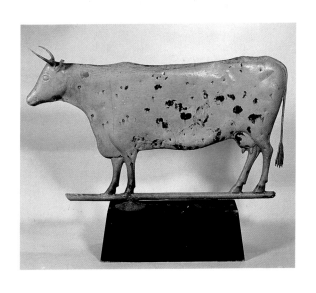

Possibly L. W. Cushing & Sons
Weather Vane: Cow, Waltham, Massachusetts, 1870/80
Molded and painted copper, 17 x 28 x 6 in.
(43.2 x 71.1 x 15.2 cm)

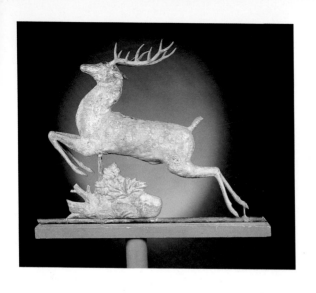

Possibly W. A. Snow & Co. or Harris & Co.
Weather Vane: Leaping Stag and Rocky Knoll, New England,
possibly Boston, 1870/1900. Molded and gilded sheet copper,
27 x 35¼ x 3½ in. (68.6 x 89.5 x 8.9 cm)

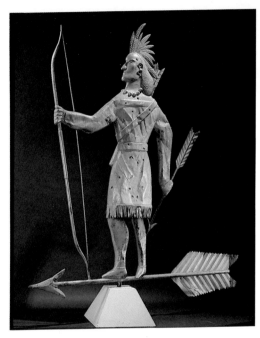

Artist unknown
Weather Vane: St. Tammany, East Branch, New York,
mid-19th century. Molded and painted copper, 102½ x 103 x 12 in.
(260.4 x 261.6 x 30.5 cm)

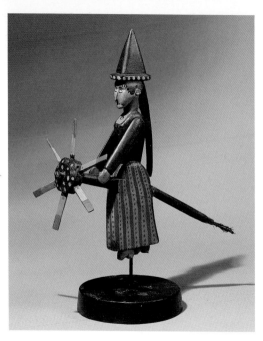

Artist unknown
Whirligig: Witch on a Broomstick, New England, 1860/80
Polychromed wood, twigs, metal, 12¼ x 12¼ x 5¼ in.
(31.1 x 31.1 x 13.3 cm)

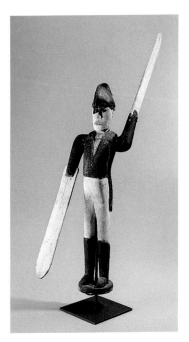

Artist unknown
Whirligig: Standing Sentinel, United States, late 19th century
Wood, paint, metal, glass eyes, 40¾ x 5 in.
(103.5 x 12.7 cm) with base

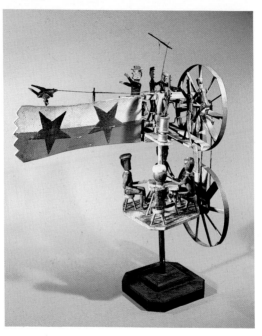

Artist unknown
Early Bird Gets the Worm, northeastern United States, c. 1920
Carved and polychromed wood, wire, 42½ x 36⅝ x 16¼ in.
(107.9 x 93 x 41.3 cm)

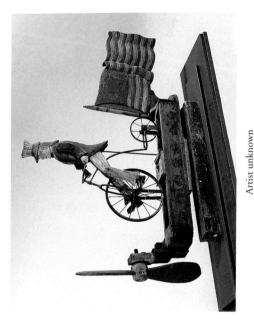

Artist unknown

Whirligig: Uncle Sam Riding a Bicycle, probably New York State,
1880/1920. Carved and polychromed wood, metal, 37 x 55½ x 11 in.
(93.9 x 140.9 x 27.9 cm)

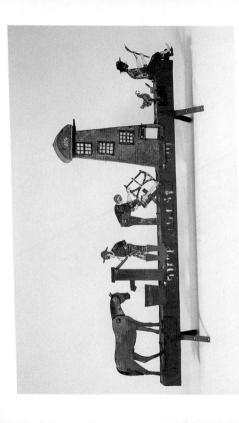

Artist unknown
Farm Vignette, United States, early 20th century
Metal, glass, paint, 65 in. (165.1 cm) high

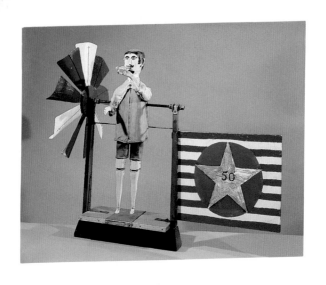

Artist unknown
Whirligig: Bugler, New York State, c. 1950
Painted wood, metal, cloth, 48 in. (121.9 cm) long

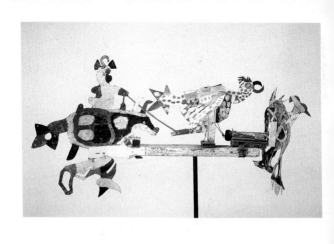

David Butler (b. 1898)
Windmill, Patterson, Louisiana, c. 1950
Painted tin, wood, and plastic, 29¼ x 49½ x 24¼ in.
(74.3 x 125.7 x 61.6 cm)

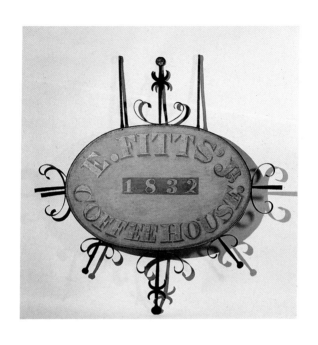

Artist unknown
Trade Sign: E. Fitts, Jr.'s Store and Coffeehouse (two-sided),
vicinity of Shelburne, Massachusetts, 1832

172 Polychromed wood, wrought iron, 22⅜ x 34½ in. (56.8 x 87.6 cm)

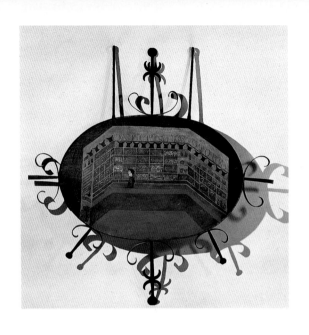

Artist unknown
Trade Sign: E. Fitts, Jr.'s Store and Coffeehouse (two-sided),
vicinity of Shelburne, Massachusetts, 1832
Polychromed wood, wrought iron, 22⅜ x 34½ in. (56.8 x 87.6 cm) 173

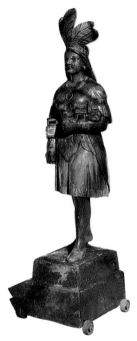

Samuel Robb (1851–1928)
Indian Maiden, New York, c. 1875/1900
Carved and polychromed wood, 56 in. (142.2 cm) high

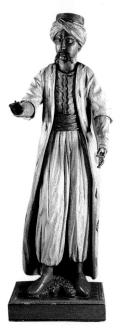

Artist unknown
Turk, eastern United States, 1860/1900
Carved and polychromed wood, 77 x 28 x 28 in.
(195.6 x 71.1 x 71.1 cm)

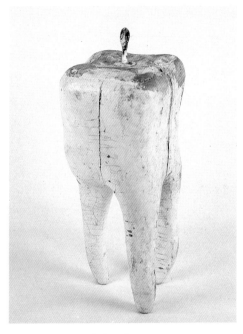

Artist unknown
Tooth, possibly New Hampshire, 1850/80
Wood, metal, paint, 26 x 12¼ x 11¼ in. (66 x 31.1 x 28.6 cm)

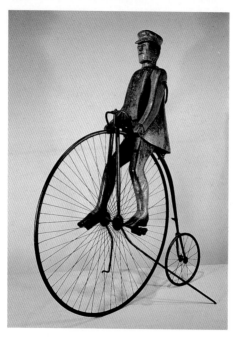

Amidée T. Thibault (1865–1961)
Bicycle, Livery, Carriage, and Paint Shop, St. Albans, Vermont,
1895/1905. Columbia bicycle, painted wood, 84 x 66 x 36 in.
(213.4 x 167.6 x 91.4 cm)

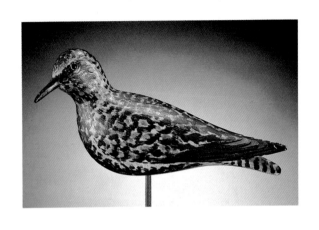

A. Elmer Crowell (1862–1951)
Decoy: Black-Bellied Plover, East Harwich, Massachusetts, c. 1910
Painted wood, glass, 5⅝ x 9⅞ x 2⅞ in. (14.3 x 25.1 x 7.3 cm)

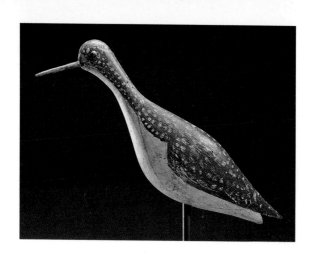

Artist unknown
Decoy: Greater Yellowlegs, region unknown, c. 1910
Wood, 15 in. (38.1 cm) long

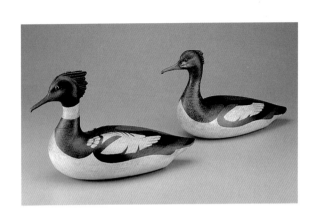

Lothrop T. Holmes (1824–1899)
Decoys: Pair of Red-Breasted Mergansers: Drake and Hen,
Kingston, Massachusetts, 1860/70
Painted wood, glass, each 9½ x 16 x 6 in. (24.1 x 40.6 x 15.2 cm)

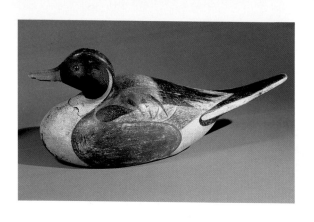

Steve Ward (1895–1976) and Lemuel Ward (b. 1896)
Decoy: Pintail Drake, Crisfield, Maryland, c. 1935
Painted wood, glass, 7⅛ x 18 x 6⅛ in. (18.1 x 45.7 x 15.6 cm)

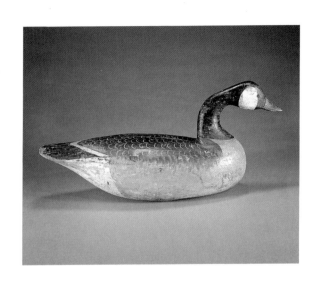

Ira Hudson (1876–1949)
Decoy: Canada Goose, Chincoteague Island, Virginia, c. 1920
Painted wood, 11 x 25½ x 8¼ in. (27.9 x 64.8 x 20.9 cm)

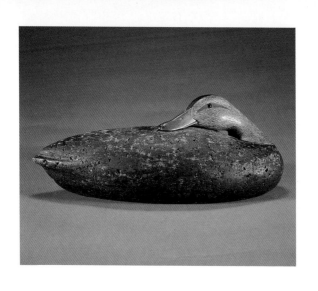

Charles E. "Shang" Wheeler (1872–1949)
Decoy: Black Duck, Stratford, Connecticut, c. 1930
Cork, wood, glass, 5⅞ x 16 x 6¾ in. (14.9 x 40.6 x 17.2 cm)

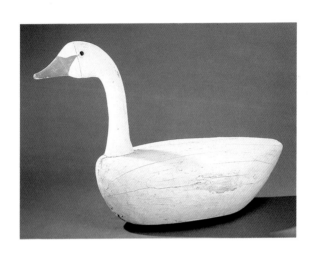

Artist unknown
Decoy: Swan, eastern United States, early 20th century
Painted wood, glass eyes, 17 x 11¼ x 5 in. (43.2 x 28.6 x 12.7 cm)

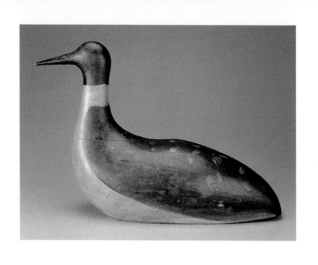

Artist unknown
Decoy: Loon, probably New England, early 20th century
Painted wood, 19 x 12 in. (48.3 x 30.5 cm)

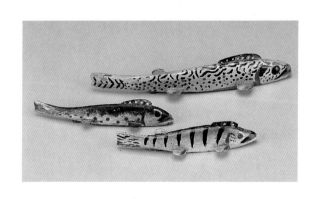

Oscar Peterson (1887–1951)
Fish Decoy: Perch, Cadillac, Michigan, c. 1930
Wood, metal, paint, 1 x 5 x 1¼ in. (2.5 x 12.7 x 3.2 cm)

Artist unknown
Fish Decoy, probably Michigan or Minnesota, 1930/50
Painted wood, metal fins, metal base, 2¼ x 5¼ x 12¼ in.
(5.7 x 13.3 x 31.1 cm)

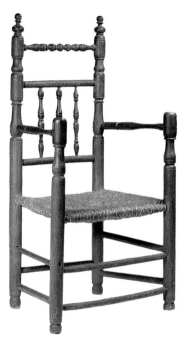

Artist unknown
"Carver" Armchair, New England, late 17th century
Turned and painted wood, rush seat, 45½ x 22¾ x 18 in.
(115.6 x 57.8 x 45.7 cm)

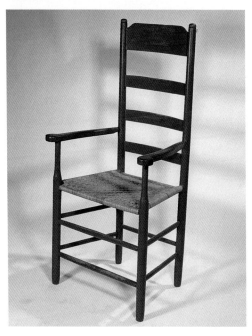

Artist unknown
Ladder Back Armchair, Kentucky, late 19th century
Stained wood, splint seat, 45½ in. (115.6 cm) high

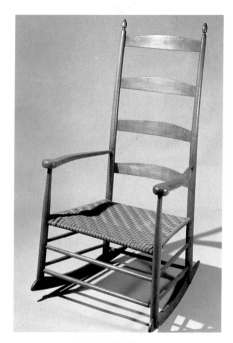

Unidentified Shaker
Rocking Chair, Mount Lebanon, New York, 1850/75
Maple, woven tape seat, 45 x 24⅞ x 25¾ in.
(114.3 x 63.2 x 65.4 cm)

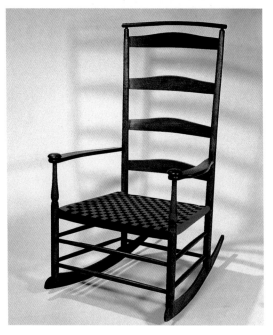

R. M. Wagan & Co. (dates unknown)
#7 Shaker Rocking Chair with Arms, South Family,
Mount Lebanon, New York Shaker Community, 1875/1900
Wood and cotton, 40½ x 25¼ x 31 in. (102.9 x 64.1 x 78.7 cm) 191

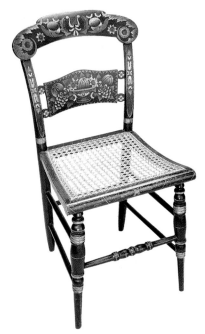

Stamped: "L. Hitchcock Hitchcocksville, Conn. Warrented"
Side Chair, Hitchcocksville, Connecticut, 1826/29
Painted and stenciled wood, 34¾ x 18 x 15 in.
(88.3 x 45.7 x 38.1 cm)

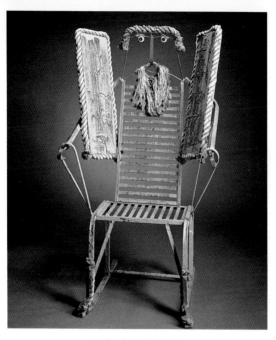

Richard Dial (b. 1955)
Comfort of Moses, Bessemer, Alabama, 1988
Steel, wood, hemp, enamel paint, 57 x 33 x 32½ in.
(144.8 x 83.8 x 82.6 cm)

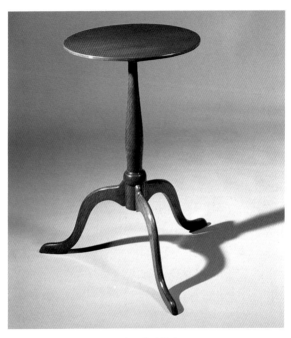

Unidentified Shaker
Tripod Base Round Stand, probably Mount Lebanon,
New York, c. 1850/75

Cherry, 26 x 20 x 19¾ in. (66 x 50.8 x 50.2 cm)

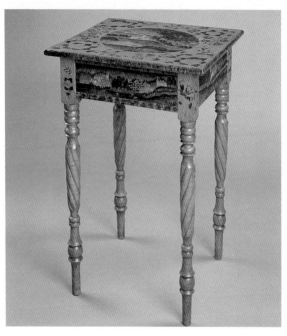

Artist unknown
Worktable, New Hampshire, 1810/25
Painted tiger maple, 29 x 19 x 18 in. (73.7 x 48.3 x 45.7 cm)

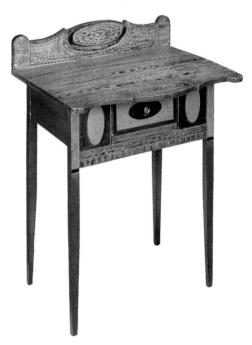

Artist unknown
Federal Sideboard Table, New England, 1820/35
Grain painted and decorated wood, brass knobs, 34⅞ x 26 x 20 in.
(88.6 x 66 x 50.8 cm)

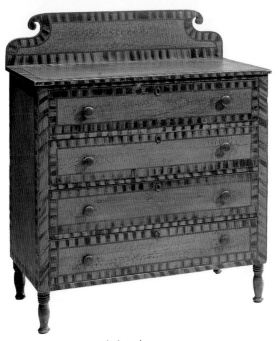

Artist unknown
Chest of Drawers, probably Maine, c. 1830
Painted and grained wood, 49 x 42½ x 20½ in.
(124.5 x 107.9 x 52.1 cm)

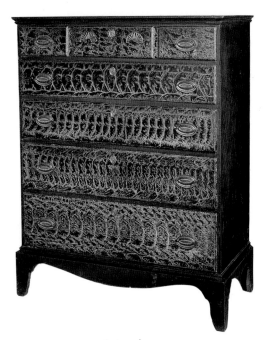

Artist unknown
Chest of Drawers, probably New Hampshire, c. 1800
Painted and grained pine and maple, 46 x 37 x 17¾ in.
(116.8 x 93.9 x 45.1 cm)

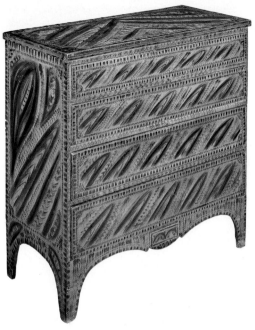

Thomas Matteson (dates unknown)
Blanket Chest, vicinity of South Shaftsbury, Vermont, c. 1825
Painted wood, 40 in. (101.6 cm) high

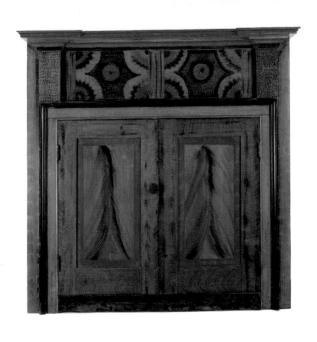

Artist unknown
Painted Mantel, Somerset County, Pennsylvania, c. 1830.
Painted and grained pine and poplar; mantel 56 x 57¼ x 7¼ in.
200 (142.2 x 145.4 x 18.4 cm), door 81½ x 36 x 1½ in. (207 x 91.4 x 3.8 cm)

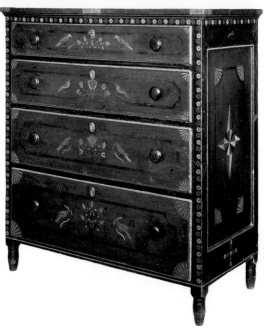

Possibly Johannes Mayer (1794–1883)
Chest of Drawers, Mahantango Valley, Pennsylvania, 1830
Paint and decorated pine and poplar, 47½ x 43⅜ x 22 in.
(120.7 x 110.2 x 55.9 cm)

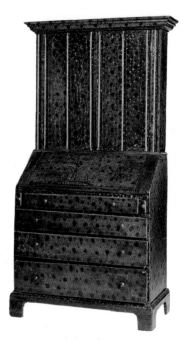

Artist unknown
Queen Anne Secretary, New England, 1760/80
Painted and decorated maple and pine, 67¾ x 37 x 16¾ in.
(172.1 x 93.9 x 42.6 cm)

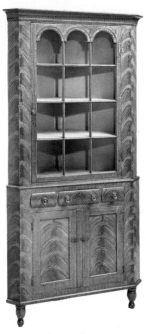

Artist unknown
Corner Cupboard, Pennsylvania, 1830/40
Painted wood, 85 x 41½ x 25 in. (215.9 x 105.4 x 12.7 cm)

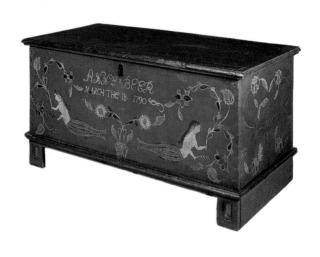

Artist unknown
Dower Chest with Mermaid Decoration, Pennsylvania, 1790
Painted and decorated pine, iron, 24¾ x 50½ x 23¾ in.
(62.9 x 128.3 x 60.3 cm)

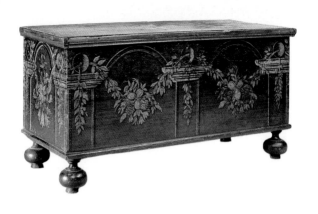

Artist unknown
Blanket Chest, Hudson River Valley, New York, 1792
Painted pine, 24 x 48 x 20 in. (60.9 x 121.9 x 50.8 cm)

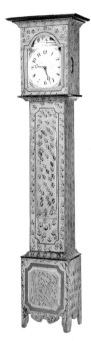

Artist unknown; dial signed: "L. W. Lewis"
Tall Case Clock, probably Connecticut, 1810/35
Painted and decorated pine case, iron works, 87 x 21½ x 12¾ in.
(220.9 x 54.6 x 32.4 cm)

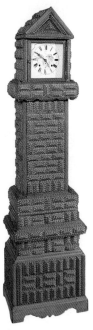

Artist unknown; Seth Thomas works
Tramp Art Clock, United States, c. 1900
Carved wood case, paper face with watercolor decoration, metal,
71 x 19 x 21 in. (180.3 x 48.3 x 53.3 cm)

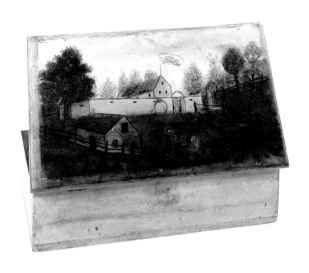

John Henry Shop (dates unknown)
Paint Box with Scenic View, New Hampshire
Painted wood, 8 x 15 x 4½ in. (20.3 x 38.1 x 11.4 cm)

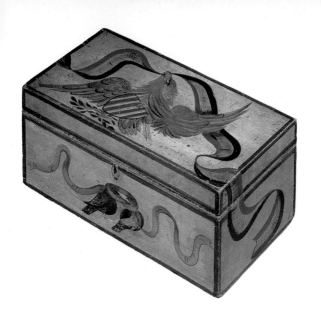

Artist unknown
Trinket Box with Eagle Decorations, New England, 1820/40
Painted and decorated wood with grained interior,
6⅜ x 14⅞ x 8⅛ in. (16.2 x 37.8 x 20.6 cm)

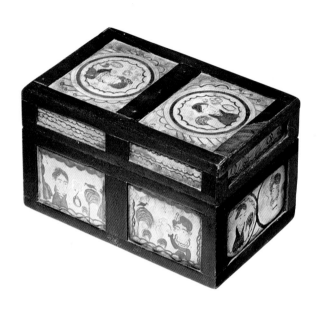

Artist unknown
Trinket Box with Portraits, New England, 1825/35
Watercolor, pencil, and ink on paper panels under glass,
wood, brass, 4½ x 8 x 5⅛ in. (11.4 x 20.3 x 13 cm)

Artist unknown
Painted Box, Pennsylvania, c. 1835
Painted wood, 1¾ x 5¼ x 3⅝ in. (4.5 x 13.3 x 9.2 cm)

Maker unknown
Paint Box belonging to Erastus Salisbury Field, Leverett,
Massachusetts, date unknown. Wood, paint, original powder,
15 x 24¾ x 9 in. (38.1 x 62.9 x 22.9 cm)

Moses Eaton Sr. (1753–1833) or Jr. (1796–1886)
Sample Box Containing Ten Panels, Dublin, New Hampshire,
1800/30. Painted and decorated pine, brass; box 8¾ x 15⅟₁₆ x 2⅝ in.
(22.2 x 38.3 x 6.7 cm), panels 6⅞ x 14 x ⅛ in. (17.5 x 35.6 x .3 cm)

213

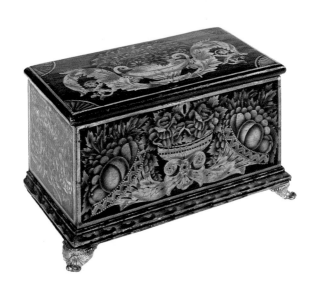

Artist unknown; initialed "R.A.C."
Box, possibly Saratoga Springs, New York, c. 1840
Painted and stenciled wood, 8⅛ x 15½ x 8¼ in.
(20.6 x 39.4 x 20.9 cm)

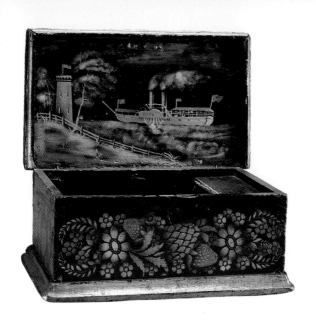

Artist unknown
Box, United States, c. 1840
Painted and stenciled wood, 5½ x 13 x 7⅝ in.
(13.9 x 33 x 19.4 cm)

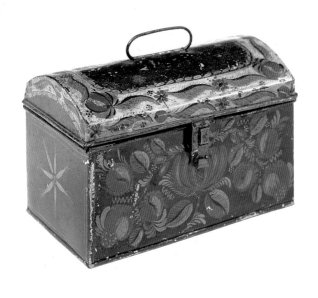

Ann Butler (1813–1887)
Trunk, Greenville, New York, c. 1830
Painted tinplate, 6¾ x 3¾ x 4⅛ in. (17.2 x 9.5 x 10.5 cm)

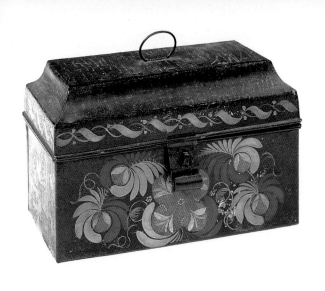

Buckley Shop (1807–c. 1840)
Platform Top Trunk, Maine, c. 1830
Painted tinplate, 5⅜ x 8½ x 4¼ in. (13.7 x 21.6 x 10.8 cm)

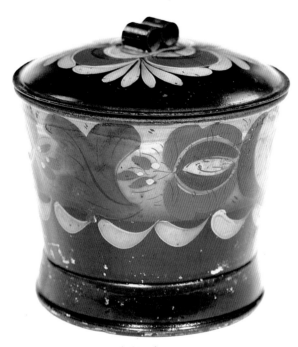

Artist unknown
Sugar Bowl, Pennsylvania, c. 1925
Painted tin, 3¾ x 4¼ in. (9.5 x 10.8 cm)

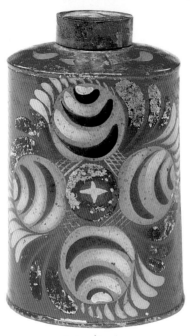

Artist unknown
Canister, probably Pennsylvania, c. 1825
Painted tin, 5⅛ x 3½ x 2¾ in. (13 x 8.9 x 7 cm)

Elder William Dumont (1851–1930)
Nesting Grain Measures,
Sabbathday Lake Shaker Village, Maine, c. 1900
Wood and iron nails, various dimensions

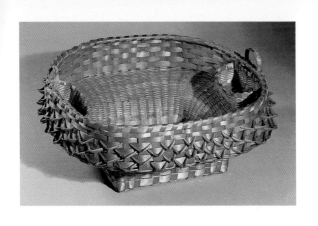

Artist unknown
Sewing Basket, northeastern United States, c. 1920
Ash splint, red dye, wood, 5¾ x 13½ in. (14.6 x 34.3 cm) diameter

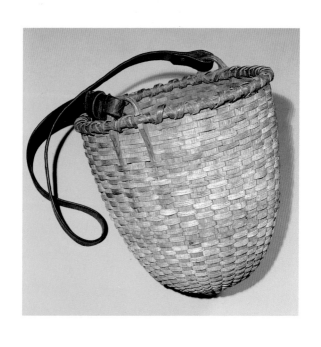

Artist unknown
Horse Feeding Basket, Connecticut, c. 1890
Narrow oak splints, leather, brass, 15¼ x 13½ in.
(38.7 x 34.3 cm) diameter

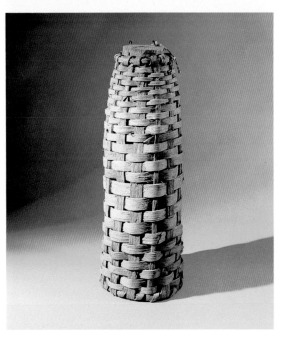

Artist unknown
Eel Basket, Chesapeake Bay area, Virginia, c. 1900
Broad oak splints, carved wood stopper, string, 22 x 9 in.
(55.9 x 22.9 cm) diameter

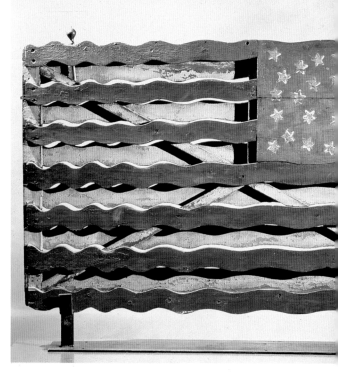

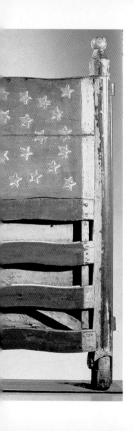

Artist unknown
Flag Gate, Jefferson County,
New York, c. 1876
Polychromed wood, iron, brass,
39½ x 57 x 3¾ in.
(100.3 x 144.8 x 9.5 cm) 225

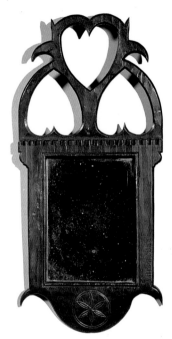

Artist unknown
Mirror with Carved Hearts, possibly Pennsylvania, 1750/80
Carved and painted pine, mirror glass, 20 x 9⅜ x 1⅛ in.
(50.8 x 23.8 x 2.9 cm)

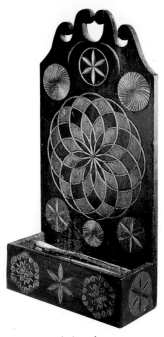

Artist unknown
Hanging Candle Box, Connecticut River Valley, 1790/1810
Carved and painted wood, 24⅝ x 12¾ x 5⅜ in.
(62.6 x 32.4 x 13.7 cm)

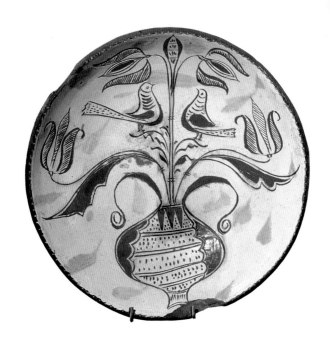

Artist unknown
Sgraffito Plate, Pennsylvania, c. 1820
Glazed redware with incised decoration,
2⅞ x 12⅝ in. (7.3 x 32.1 cm)

Artist unknown
Pie Crust Plate, Pennsylvania, c. 1900
Glazed redware, 10¼ in. (26 cm) diameter

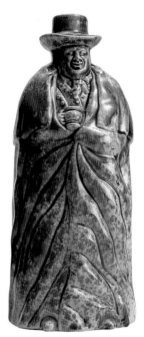

Lyman Fenton & Company (dates unknown)
Coachman Jug, Bennington, Vermont, c. 1849
Rockingham or flint enamel, 10½ x 4⅜ in. (26.7 x 11.1 cm)

Artist unknown
Covered Redware Jar, probably Pennsylvania or Connecticut, 1850/60
Glazed redware, 6⅝ in. (16.8 cm) (without cover) x 5½ in.
(13.9 cm) diameter

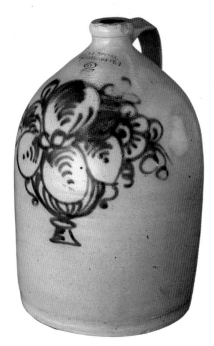

J. & E. Norton
Jug, Bennington, Vermont, 1850/59
Stoneware with cobalt decoration, 13½ x 9 in.
(34.3 x 22.9 cm) diameter

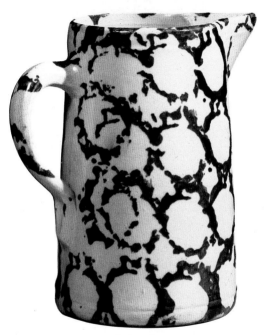

Artist unknown
Pitcher, New Jersey or Ohio, 1880/1910
Stoneware with sponged cobalt decoration, 8⅞ x 8¼ x 5⅞ in.
(22.5 x 20 x 14.9 cm)

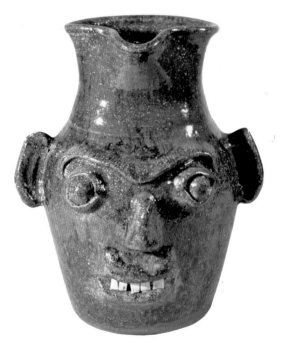

Burlon Craig (b. 1914)
Grotesque Face Jug, Vale, North Carolina, c. 1978
Stoneware, 11 x 9½ x 9⅜ in. (27.9 x 24.1 x 23.8 cm)

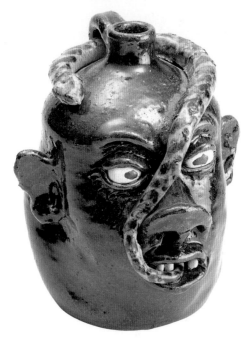

Lanier Meaders (b. 1917)
Grotesque Face Jug, Georgia, 1976
Ash-glazed stoneware, 8⅝ x 7⅝ x 7⅜ in. (21.9 x 19.4 x 18.7 cm)

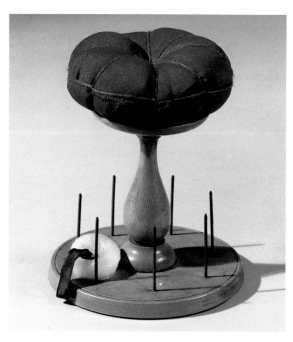

Unidentified Shaker
Spool Stand, United States, 1880/1930
Maple, stuffed cotton, metal, beeswax, 5⅞ x 5⅝ in.
(14.9 x 14.3 cm)

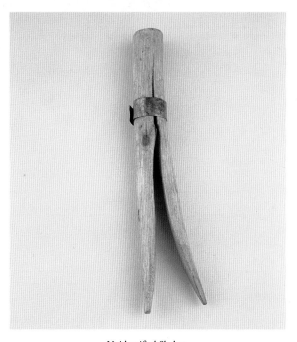

Unidentified Shaker
Clothespin, Pleasant Hill, Kentucky, c. 1900
Wood, metal band, 5⅛ x 1⅛ x ½ in. (13 x 2.9 x 1.3 cm)

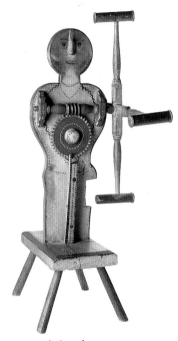

Artist unknown
Yarn Reel, probably Connecticut, 1825/50
Carved, turned, and polychromed wood, 39¼ x 16 x 26⅛ in.
(99.7 x 40.6 x 66.4 cm)

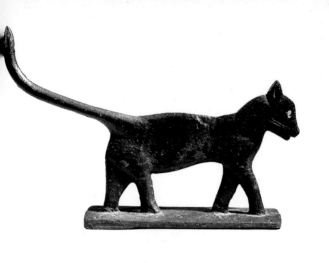

Artist unknown
Cat Bootscraper, United States, c. 1900
Cast iron, 11⅜ x 17½ x 3 in. (28.9 x 44.5 x 7.6 cm)

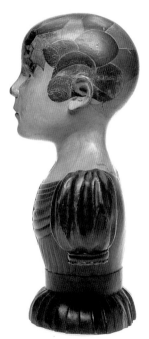

Attributed to Asa Ames (1823–1851)
Phrenological Head, Evans, Erie County, New York, 1847/50
Carved and polychromed wood, 16⅜ x 13 x 7⅛ in.
(41.6 x 33 x 18.1 cm)

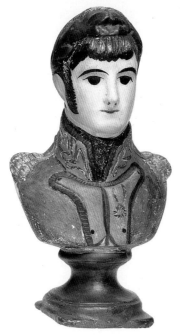

Artist unknown
Bust of a Man, eastern United States, c. 1860/1900
Polychromed plaster of paris, 14 x 8⅛ x 5¾ in.
(35.6 x 20.6 x 14.6 cm)

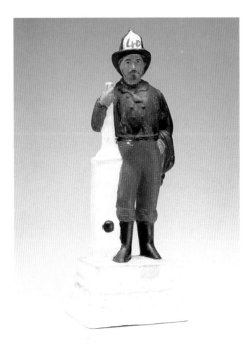

Artist unknown
Fireman on White Base, eastern United States, 1860/1900
Polychromed plaster of paris, height 14 in. (35.6 cm)

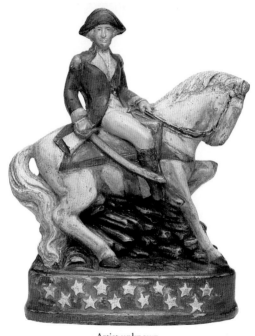

Artist unknown
George Washington on Horseback, eastern United States, 1860/1900
Polychromed plaster of paris, 12 x 9¾ x 3½ in.
(30.5 x 24.8 x 8.9 cm)

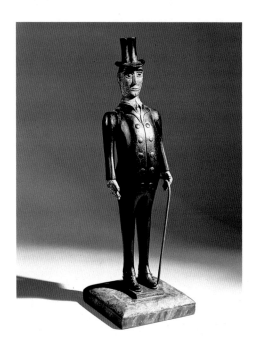

Artist unknown
Man in a Top Hat with a Cane, northeastern United States, c. 1890
Carved and painted wood figure, painted and smoke-decorated
base, 23½ x 7½ x 7½ in. (59.7 x 19.1 x 19.1 cm)

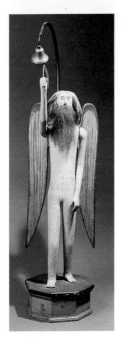

Artist unknown
Father Time, Mohawk Valley, New York, c. 1910
Carved and polychromed wood, metal, hair, 52⅛ x 13⅞ x 14½ in.
(132.4 x 35.3 x 36.8 cm)

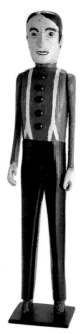

Artist unknown
Man in a Green Shirt with White Suspenders, late 19th century
Metal, glass eyes, wood, 25½ x 5½ x 3½ in.
(64.8 x 13.9 x 8.9 cm)

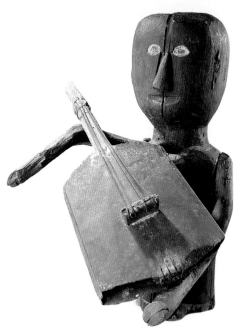

Clark Coe (1847–1919)
Musician With Lute, Killingworth, Connecticut, early 20th century
Wood figure, metal and wood lute, height: 30 in. (76.2 cm)

Denzil Goodpaster (b. 1908)
Woman, Ezel, Kentucky, c. 1983
Carved and polychromed wood, 36 in. (91.4 cm) long

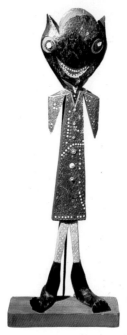

"Poppsy" Schaffer (1880–1964)
Liza, Mountainair, New Mexico, c. 1935
Polychromed wood, 59 x 14 x 13⅝ in. (149.9 x 35.6 x 34.6 cm)

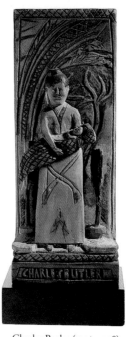

Charles Butler (1902–1978)
Pharoah's Daughter with Infant Moses, Clearwater, Florida, 1961
Wood, 10¼ x 7 x 2⅛ in. (26 x 17.8 x 5.4 cm)

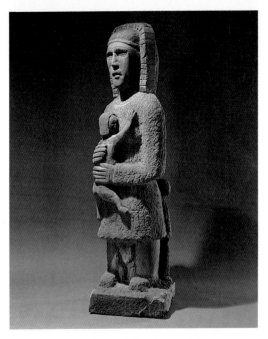

Ernest "Popeye" Reed (1924–1985)
Woman with Two Children and Cat, Jackson County, Ohio, c. 1968
Carved gray sandstone, 60 x 12 x 15 in. (152.4 x 30.5 x 38.1 cm)

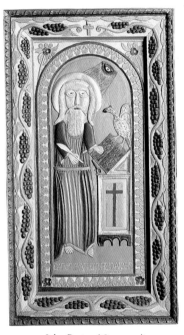

John Perates (1895–1970)
Saint John the Evangelist, Portland, Maine, 1938/70
Carved, polychromed, and varnished wood, 49¼ x 27½ x 5½ in.
(125.1 x 69.9 x 13.9 cm)

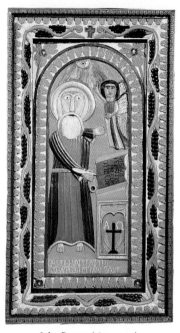

John Perates (1895–1970)
Saint Matthew, Portland, Maine, 1938/70
Carved, polychromed, and varnished wood, 49¼ x 27½ x 5½ in.
(125.1 x 69.9 x 13.9 cm)

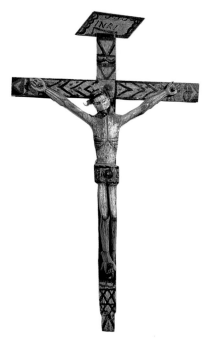

Attributed to Jose Benito Ortega (1858–1941)
Bulto, La Cueva, New Mexico, 1870/1900
Gessoed and polychromed wood, iron and leather, 45 x 27⅜ x 4¾ in.
(114.3 x 69.5 x 12.1 cm)

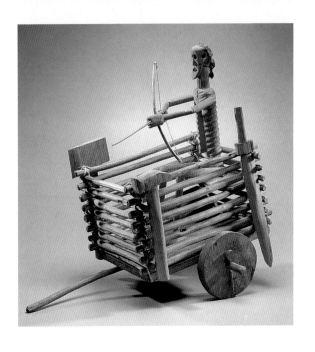

George T. López (b. 1900)
Death Cart, Cordova, New Mexico, c. 1965
Cottonwood, 24 x 26 x 12 in. (60.9 x 66 x 30.5 cm)

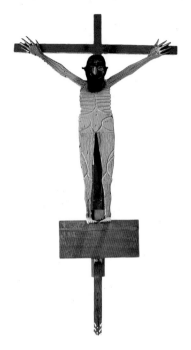

Chester Cornett (1912–1981)
Crucifix, Dwarf County, Kentucky, c. 1968
Polychromed wood, 96 x 48 in. (243.8 x 121.9 cm)

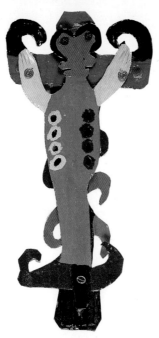

David Butler (b. 1898)
Christ on the Cross, Patterson, Louisiana, c. 1983
Sheet tin, paint, wire, found objects, 24⅝ x 11¼ x½ in.
(62.6 x 28.6 x 1.3 cm)

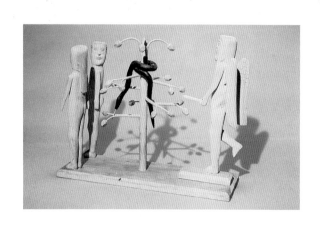

Edgar Tolson (1904–1984)
Expulsion, Campton, Kentucky, 1969/70
Paint and pencil on wood, 18 x 14½ x 7 in.
(45.7 x 36.8 x 17.8 cm)

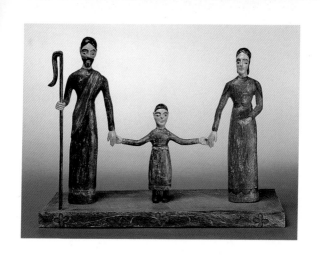

Felix Lopez (b. 1942)
La Familia Sagrada, Espanola, New Mexico, c. 1979
Carved and polychromed wood, 10½ x 12 x 3 in.
(26.7 x 30.5 x 7.7 cm)

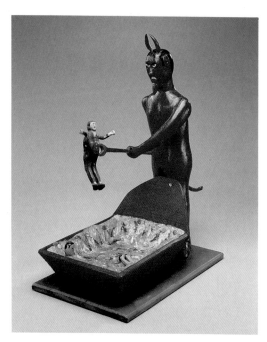

Miles Burkholder Carpenter (1889–1985)
The Devil and the Damned, Waverly, Virginia, c. 1972
Painted wood and cellophane, 19 in. (48.3 cm) high

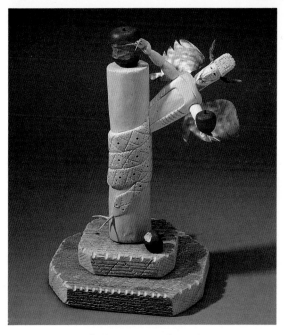

Eluid Levi Martinez (b. 1944)
Temptation, Santa Fe, New Mexico, 1986
Wood, brass, paint, nails, 12 x 7½ x 5¾ in. (30.5 x 19.1 x 14.6 cm)

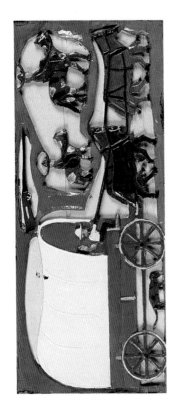

Elijah Pierce (1892–1984)
Seeking Gold in the West, Columbus, Ohio, c. 1950
Carved and polychromed wood, 12 x 24½ in. (30.5 x 62.2 cm)

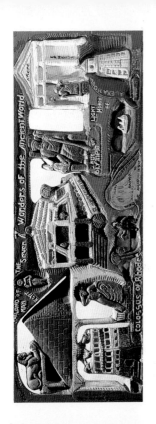

Josephus Farmer (1894–1989)
The Seven Wonders of the Ancient World, Milwaukee, 1970/75
Redwood, enamel paint, 30 x 50 in. (76.2 x 127 cm)

263

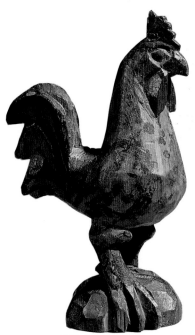

Wilhelm Shimmel (1817–1890)
Rooster, Carlisle, Pennsylvania, 1870/90
Polychromed wood, 8 x 5⅛ x 2⅝ in. (20.3 x 13 x 6.7 cm)

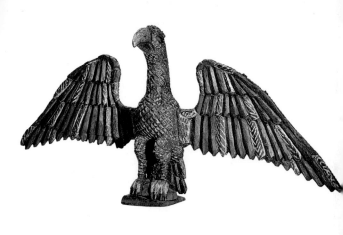

Wilhelm Schimmel (1817–1890)
Eagle with Outspread Wings, Carlisle, Pennsylvania, 1870/90
Carved, gessoed, and painted pine, 20 x 41 x 6½ in.
(50.8 x 104.1 x 16.5 cm)

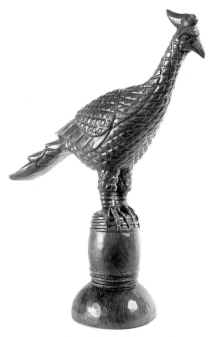

Aaron Mountz (1873–1949)
Eagle Perched on Keg, Carlisle, Pennsylvania, 1893/1918
Carved and stained pine, approximately 16 x 18 x 6 in.
(40.6 x 45.7 x 15.2 cm)

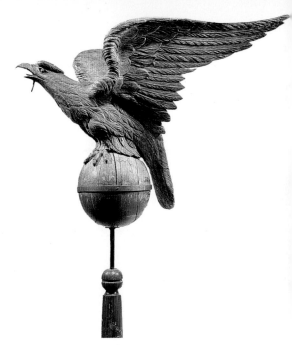

Artist unknown
Eagle, Columbia, Pennsylvania, c. 1905
Carved wood, iron, 69⅞ x 44 x 50 in. (177.5 x 111.8 x 127 cm)

Artist unknown
Red, Yellow, and Green Poodle, eastern United States, 1860/1900
Polychromed plaster of paris, 8½ x 6¾ x 4⅛ in.
(21.6 x 17.2 x 10.5 cm)

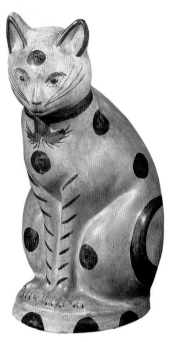

Artist unknown
Seated Cat, United States, 1860/1900
Polychromed plaster of paris, 15⅝ x 8¾ x 10⅛ in.
(39.7 x 22.2 x 25.7 cm)

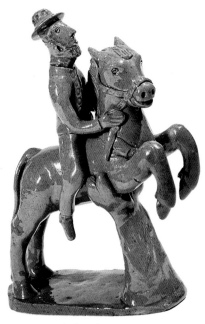

Artist unknown
Horse and Rider, probably Pennsylvania, 1850/75
Glazed redware, 8 x 5¾ x 2⅝ in. (20.3 x 14.6 x 6.7 cm)

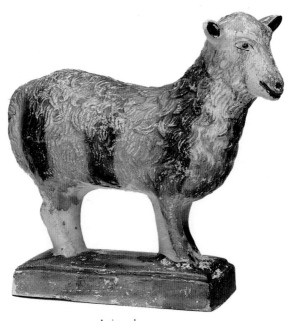

Artist unknown
Standing Sheep on Green Base, eastern United States, 1860/1900
Polychromed plaster of paris, 7⅛ x 8 x 3 in. (18.1 x 20.3 x 7.6 cm)

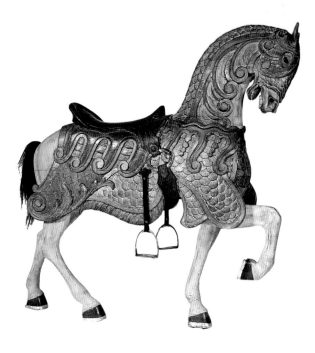

Stein and Goldstein (dates unknown)
Armoured Carousel Horse, Coney Island, New York City, 1912/17
Wood, paint, leather, and horsehair, approximately
66 in. (167.6 cm) long

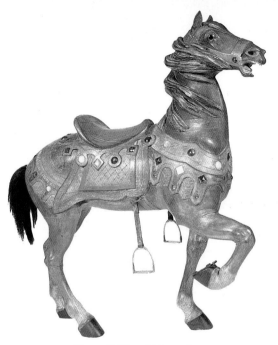

Marcus C. Illions (1865–1949)
Carousel Horse with Jewels, Coney Island, New York City, c. 1915
Polychromed wood, leather, metal, horsehair, colored glass,
46½ x 42 x 10 in. (118.1 x 106.7 x 25.4 cm)

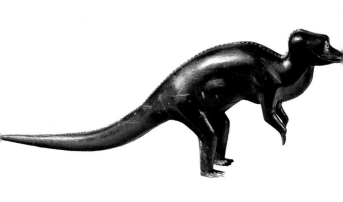

Fred Alten (1872–1945)
Dinosaur, Wyandotte, Michigan, 1915/25
Carved and painted wood, 9⅜ x 24⅝ x 3½ in.
(23.8 x 62.6 x 8.9 cm)

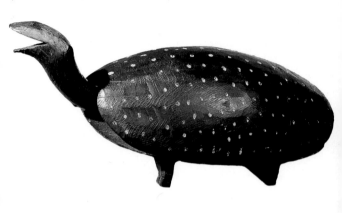

Artist unknown
Turtle, 19th century
Carved and painted wood, 7¼ x 20⅝ x 7⅝ in.
(18.4 x 52.4 x 19.4 cm)

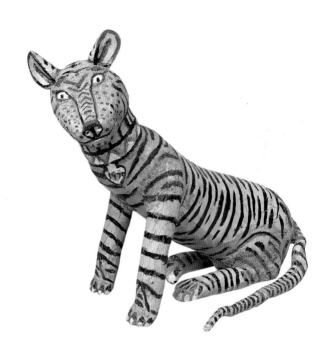

Felipe Benito Archuleta (1910–1991)
Seated Tiger, Tesuque, New Mexico, 1970
Cottonwood, paint, and gesso, 30¾ x 16¾ x 35 in.
(78.1 x 42.6 x 88.9 cm)

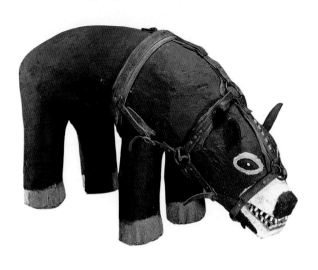

Leroy Archuleta (b. 1949)
Black Bear with Leather Harness, Tesuque, New Mexico, 1988
Painted wood with leather harness, metal toes, 59 x 18 x 12 in.
(149.9 x 45.7 x 30.5 cm)

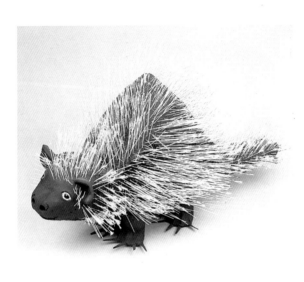

David Alvarez (b. 1953)
Porcupine, Santa Fe, New Mexico, c. 1981
Cottonwood, paint, straw, marbles, and plastic, 19 x 13 x 35 in.
(48.3 x 33 x 88.9 cm)

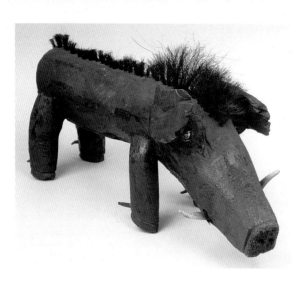

Mike Rodriquez (b. 1948)
Wild Boar, Rowe Mesa, New Mexico, 1984
Cottonwood, horsehair, marbles, leather, 11½ x 7½ x 26½ in.
(29.2 x 19.1 x 67.3 cm)

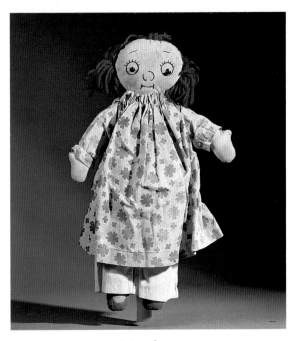

Artist unknown
Raggedy Ann, United States, 1910/20
Cotton, muslin, shoe buttons, yarn, ribbon, 17 x 11¼ x 2⅜ in.
(43.2 x 28.6 x 6 cm)

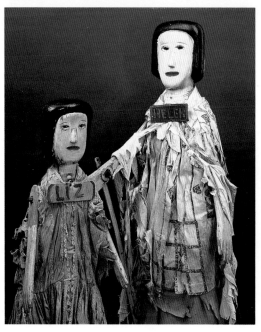

Calvin Black (1903–1972) and Ruby Black (1915–1980)
Possum Trot Figures: Liz and Helen, Yermo, California, c. 1955
Carved and painted redwood, each 33 x 10 x 7 in.
(83.8 x 25.4 x 17.8 cm)

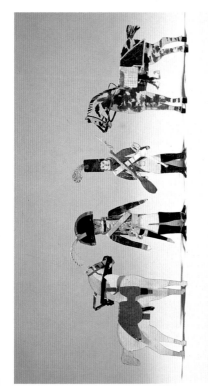

Artist unknown
Paper Dolls: Horses and Soldiers, Boston, 1840/50
Watercolor, pen and ink on cut paper and card; soldiers 4 x 2 in.
(10.2 x 5.1 cm), horses 4 x 4½ in. (10.2 x 11.4 cm)

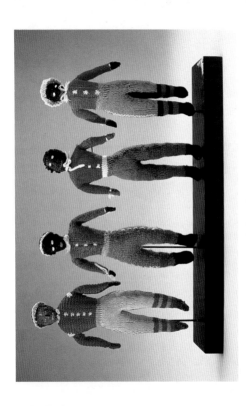

Artist unknown
Four Hand-knitted and Stuffed Dolls, possibly Maine, 1870/80
Wool yarn with embroidered features, stuffed with cotton and straw
or sawdust, 11½ x 5½ x 1¼ in. (29.2 x 13.9 x 3.2 cm)

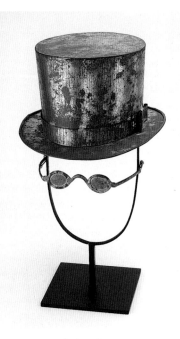

Artist unknown
Man's Top Hat and Eyeglasses, Gobles, Michigan, 1880/1900
Tin, top hat 9½ x 11½ x 5¼ in. (24.1 x 29.2 x 13.3 cm);
eyeglasses 1⅛ x 5⅛ x 5⅛ in. (2.8 x 13 x 13 cm)

Artist unknown
Lady's Slippers, Gobles, Michigan, 1880/1900
Tin, 2½ x 2¾ x 9 in. (6.4 x 6.9 x 22.9 cm)

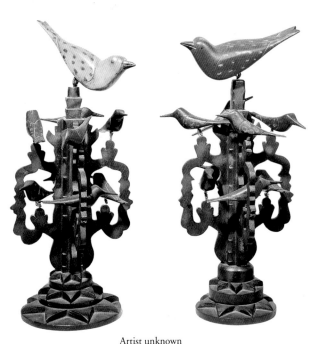

Artist unknown
Pair of Bird Trees, Pennsylvania, c. 1875
Carved and polychromed wood, wire, 15⅞ x 6 in. (40.4 x 15.2 cm)
286 diameter; 16⅝ x 6⅞ in. (42.2 x 17.5 cm) diameter

Artist unknown; signed "Osgood"
Checkerboard and Checker Box, northeastern United States,
late 19th century
Painted wood and tin, 21 x 10 in. (53.3 x 25.4 cm)

John Scholl (1827–1916)
Sunburst, Germania, Pennsylvania, 1907/16
Wood, paint, wire, and metal, 71 x 38 x 24½ in.
(180.3 x 96.5 x 62.2 cm)

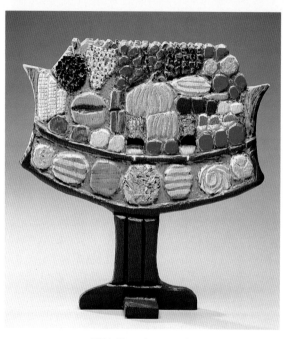

Elijah Pierce (1892–1984)
Carved Compote, Columbus, Ohio, c. 1975
Carved and painted wood, 14 x 13 x 4 in. (35.6 x 33 x 10.2 cm)

Textiles

Intricate handiwork has been a hallmark of American textile works since the eighteenth century. Textiles in the folk tradition include samplers and embroidered pictures, a variety of bedcovers including quilts and coverlets, and hooked and braided rugs.

Sewing and embroidery were essential skills for eighteenth-century women. Well-to-do schoolgirls trained in needlework created samplers of embroidery stitches that demonstrated their accomplishments in embroidering letters and decorative elements. Samplers served as reference pieces for marking linens and were often prominently displayed in the home (pages 295, 296, 298, 299). Types of samplers include band, alphabet, verse, family record, map, and combinations of these, as well as pictorial examples (page 297). Embroidered pictures such as the numerous works known as the "Boston Fishing Lady" group (page 294), usually depict pastoral scenes.

One of the largest categories of American textiles includes bedcovers, ranging from bed rugs to whole-cloth, stenciled (pages 302, 303), embroidered, and candlewick spreads to quilts and woven coverlets. The decorative woolen bed rugs (page 300) and embroidered bedcovers, popular during the eighteenth and early nineteenth centuries, provided much-needed warmth. Bed rugs were so sturdy they were once thought to be floor coverings.

Quilts are among the most appreciated of American textiles. While earlier quilts were made from remnants that included treasured apparel and household furnishing fabric, later quilts were made from more readily available yard goods. Quilts may be whole-cloth, pieced, appliqué, or a combination of these. Quilt patterns range from geometric and abstract (pages 305, 314) to representational (page 309). Common quilt pattern types include Album (page 307), Commemorative (page 310), Log Cabin (pages 316, 317), and Patriotic quilts (pages 318, 319).

Quilts have been described as metaphors for women's lives and as cultural records. The superb color

and stitchery in Amish and Mennonite quilts (pages 324, 325, 326) reflect the value systems that define these sects. Contemporary African-American quilters have incorporated African motifs and improvisational techniques in their work as expressions of their experience and identity (pages 331, 332, 333).

A desire to ornament and adorn bedcoverings has always been a part of quiltmaking. The Industrial Revolution made textiles more available and affordable, and quiltmaking became more widespread. Decorative quiltmaking culminated in the "crazy quilt" trend in the late nineteenth century. Today quiltmaking is enjoying a renaissance; contemporary quilters are producing both utilitarian and art quilts, which are created specifically for display (pages 334, 335).

Designed for warmth and strength, wool and cotton coverlets were woven with cotton warp and wool weft in halves that were then sewn together. These usually fell into one of five categories: the geometric patterned plain weave, the double-weave (page 338), the overshot (page 339), the "summer winter," and the elaborate, intricately patterned jacquard (pages

336, 337), which was introduced in the mid-1820s.

Until around 1750, rugs were considered too valuable to be used as floor coverings and were usually displayed on tabletops. By the mid-nineteenth century, imported or hand-sewn yarn rugs appeared in wealthier households. Rag-hooked and braided rugs were used in rural homes. The hooked rug, made by hooking fabric-dyed strips into a loose burlap or other backing, was usually designed with motifs of flowers, animals, people, or geometric forms. For braided rugs, strips of recycled fabric were braided and then coiled and sewn into circular or oval shapes. The Shakers produced some extraordinary examples combining vibrant color and excellent craftsmanship (page 345).

Recently, historians of America folk art have also begun to study Native American textiles; weavings such as the *Navajo Classic Child's Blanket* (page 341) are now exhibited in museums as another important facet of America's rich textile tradition.

The plates in this chapter appear in the following order: samplers and embroidered pictures, bedcovers including quilts and coverlets, and rugs.

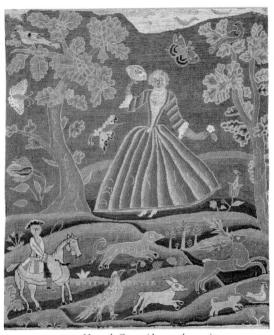

Hannah Carter (dates unknown)
Lady with a Fan, Boston, c. 1750
Crewel yarn on fine canvas, 17¾ x 16 in. (45.1 x 40.6 cm)

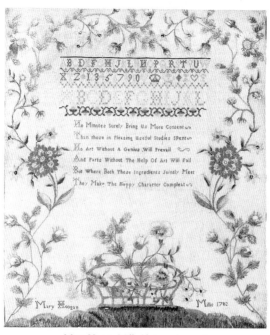

Mary Hogan Mills (dates unknown)
Sampler, England or British Isles, 1782
Silk on wool, 13¼ x 11¼ in. (33.7 x 28.6 cm)

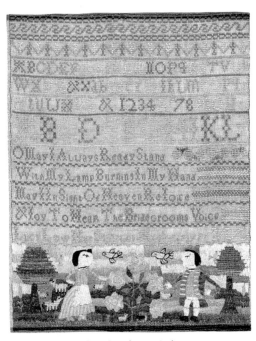

Lucy Low (1764–1842)
Sampler, Danvers, Massachusetts, 1776
Silk on linen, 14½ x 11⅜ in. (36.8 x 28.9 cm)

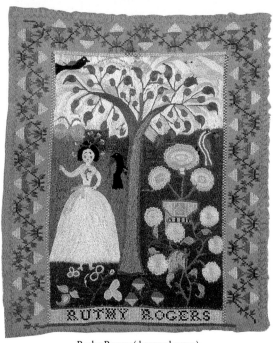

Ruthy Rogers (dates unknown)
Sampler, Marblehead, Massachusetts, c. 1789
Silk on linen, 10½ x 9 in. (26.7 x 22.9 cm)

Hannah Staples (dates unknown)
Sampler, probably Maine, late 18th century
Silk thread on linen, 21½ x 16 in. (54.6 x 40.6 cm)

Hannah Staples (dates unknown)
Sampler, probably Maine, c. 1791
Silk thread on linen, 10¾ x 10⅜ in. (27.3 x 26.4 cm)

Artist unknown
Bed Rug, Connecticut, c. 1800
Wool, 96 x 100 in. (243.8 x 254 cm)

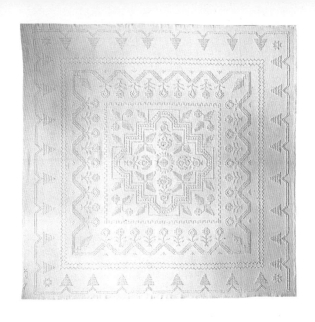

Weaver unknown; initialed "AFX"
Candlewick Spread, New York State, 1825/50
Cotton, 85 x 79¾ in. (215.9 x 202.6 cm)

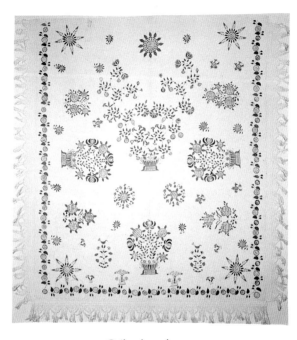

Quiltmaker unknown
Pots of Flowers Stenciled Spread, New England, 1825/35
Stenciled cotton, handmade cotton fringe on three sides,
92 x 85 in. (233.7 x 215.9 cm)

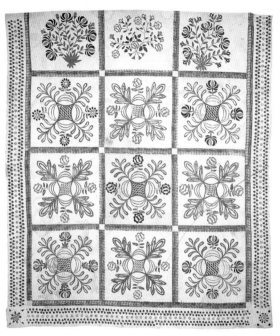

Possibly Sara Massey (dates unknown)
Stenciled Summer Spread, possibly Watertown, New York, 1825/40
Stenciled cotton, 88 x 76¼ in. (223.5 x 193.7 cm)

303

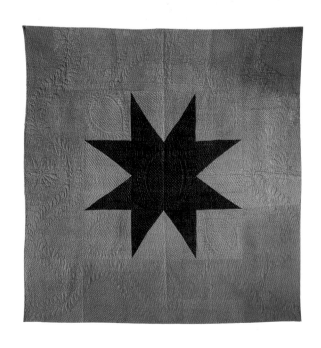

Quiltmaker unknown
Center Star Quilt, New England, 1815/25
Hand-pieced, hand-quilted calamanco; backing: two sizes of checked
wool fabric woven with wool, 100½ x 98 in. (255.3 x 248.9 cm)

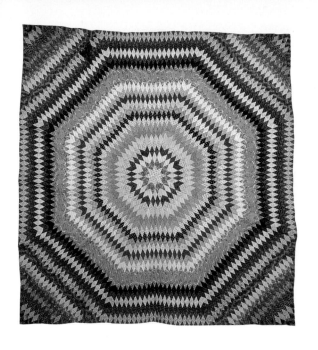

Possibly Rebecca Scattergood Savery (1770–1855)
Sunburst Quilt, Philadelphia, 1835/45
Hand-pieced, hand-quilted roller-printed cottons, 118½ x 125⅛ in.
(301 x 317.8 cm)

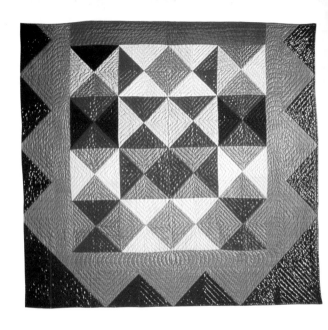

Quiltmaker unknown
Harlequin Medallion Quilt, New England, 1800/20
Pieced calamanco, 87 x 96 in. (220.9 x 243.8 cm)

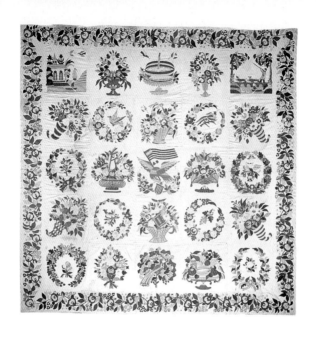

Possibly Mary Evans (1829–1916)
Baltimore-Style Album Quilt Top, possibly Baltimore, 1849/52
Hand-sewn, appliquéd cotton, ink, 109 x 105 in.
(276.9 x 266.7 cm)

Artist unknown
Patterns for "Bird of Paradise" Quilt Top, vicinity of Albany, 1853/65
Pencil on newspaper, cut and pinned, 10⅛ x 7 in.
(25.7 x 17.8 cm)

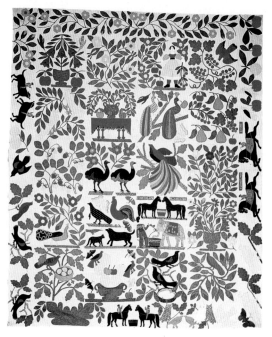

Quiltmaker unknown
"Bird of Paradise" Quilt Top, vicinity of Albany, 1858/63. Appliquéd
cotton, wool, silk including velvet on muslin, silk embroidery
including silk chenille thread, ink, 84½ x 69⅝ in. (214.6 x 176.9 cm) 309

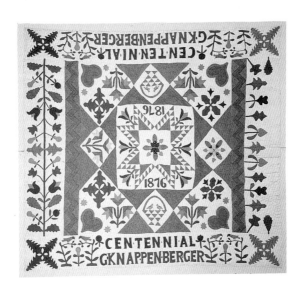

G. Knappenberger (dates unknown)
"Centennial" Quilt, probably Pennsylvania, c. 1876
Hand-pieced, hand-quilted, appliquéd, embroidered cotton,
84 x 74 in. (213.4 x 187.9 cm)

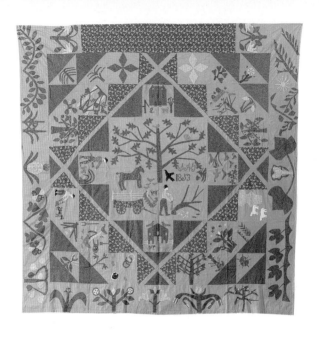

Sarah Ann Gargis (1834?–1887?)
Sarah Ann Gargis Quilt Top, Feasterville or Doylestown, Pennsylvania,
1853. Hand-sewn, pieced, and appliquéd cotton; silk , wool, and
wool embroidery; muslin back, 96 x 98 in. (243.8 x 248.9 cm)

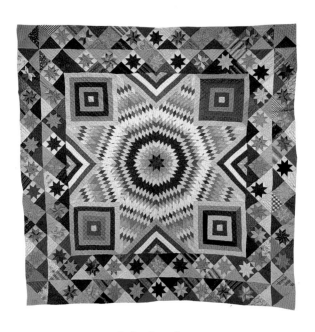

Quiltmaker unknown
Star of Bethlehem, possibly Sullivan County, New York, 1880/1900
Hand-pieced, hand-quilted silk, including satin and pattern-woven;
cotton; polished cotton backing, 99 x 94¼ in. (251.5 x 239.4 cm)

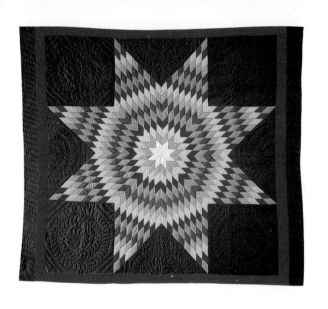

Mrs. David Bontraeger (dates unknown)
Lone Star Quilt, Emma, Indiana, 1920/30
Machine- and hand-pieced, hand-quilted cotton,
84 x 74 in. (213.4 x 187.9 cm)

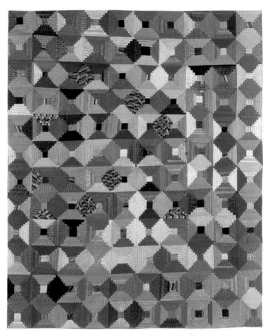

Samuel Steinberger (dates unknown)
Log Cabin, Courthouse Steps, New York City, 1890/1900
Hand-pieced silk, including satin and velvet,
69½ x 58 in. (176.5 x 147.3 cm)

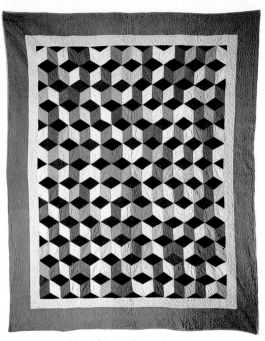

Mrs. Ed Lantz (dates unknown)
Tumbling Blocks Quilt, Elkhart, Indiana, c. 1910
Machine-pieced, hand-quilted cotton, muslin backing,
80½ x 66¼ in. (204.5 x 168.3 cm)

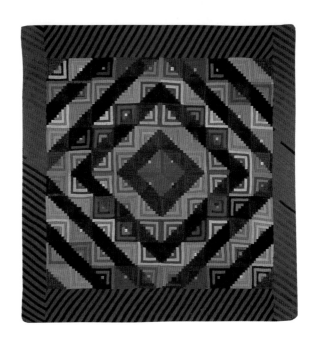

Lydia A. (Kanagy) Peachey (1863–1949)
Log Cabin: Barn Raising, Mifflin County, Pennsylvania, Black Topper,
Peachey/Zook Group, 1890/1900. Hand-pieced, hand-quilted wool
and cotton, cotton backing, 85 x 80½ in. (215.9 x 204.5 cm)

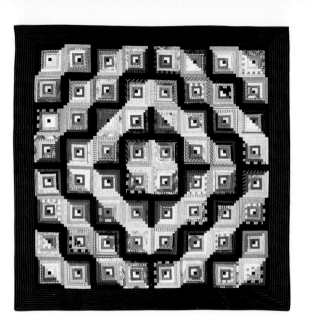

Sarah Olmstead King (dates unknown)
Log Cabin: Barn Raising, Connecticut, 1875/80
Silk including velvet and satin, ribbon, 67⅛ x 67⅛ in.
(170.5 x 170.5 cm)

Quiltmaker unknown
"Baby" Crib Quilt, possibly Kansas, 1861/75
Hand-pieced and appliquéd cotton with cotton embroidery,
36¾ x 36 in. (93.4 x 91.4 cm)

318

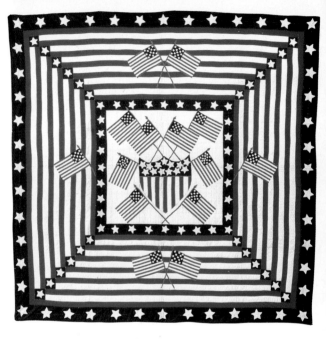

Mary C. Baxter (dates unknown)
Flag Quilt, Kearney, New Jersey, c. 1898
Machine-pieced, hand-quilted, appliquéd and embroidered cotton,
76 x 78 in. (193 x 198.1 cm)

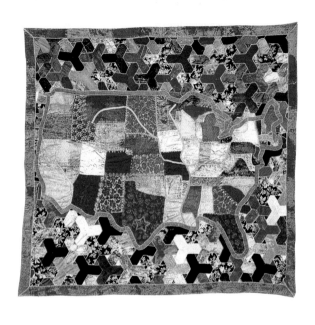

Quiltmaker unknown
Map Quilt, Virginia, 1886
Pieced silk velvets and brocades; cotton sateen backing, embroidery,
78¾ x 82¼ in. (200 x 208.9 cm)

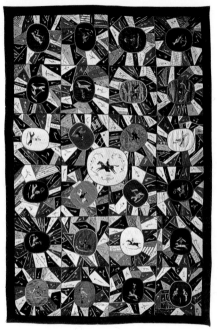

Quiltmaker unknown. *The Equestrian Quilt,* New York State,
1884/1900. Foundation pieced, appliquéd, embroidered silks,
including plain and pattern-woven, velvets, taffetas, grossgrain
ribbon, polished cotton backing, 92 x 61½ in. (233.7 x 156.2 cm) 321

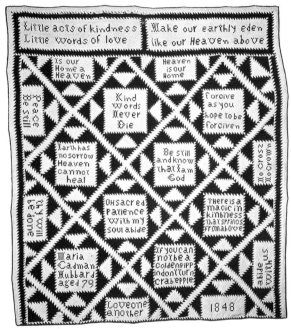

Maria Cadman Hubbard (b. 1769)
Pieties Quilt, possibly New York State, 1848
Hand-pieced, hand-quilted cotton, 88½ x 81 in.
(224.8 x 205.7 cm)

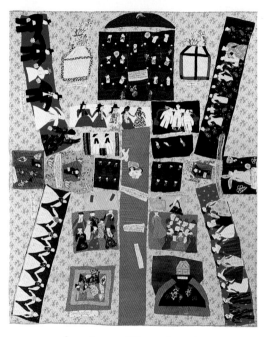

Susan Arrowood (dates unknown)
"Sacret Bible" Quilt Top, West Chester, Pennsylvania, 1875/95
Appliquéd and embroidered cotton, including lace; silk including
velvet; wool, ink, 88½ x 72 in. (224.8 x 182.9 cm)

323

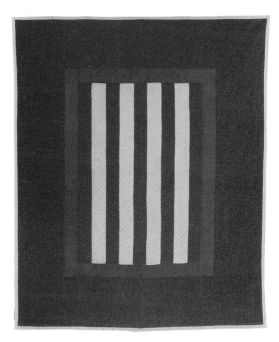

Quiltmaker unknown
Bars, Lancaster County, Pennsylvania, 1890/1900
Machine-pieced, hand-quilted wool, cotton backing, 87¼ x 72½ in.
(221.6 x 184.2 cm)

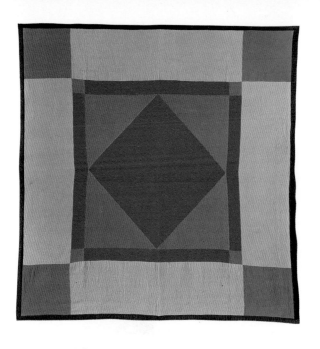

Rebecca Fisher Stoltzfus (dates unknown)
Center Diamond, Groffdale area of Lancaster County,
Pennsylvania, c. 1903
Wool, 77 x 77 in. (195.6 x 195.6 cm)

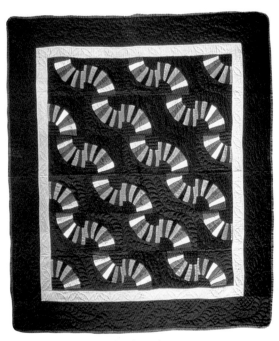

Quiltmaker unknown
Fans, Honeyville, Indiana, 1915/30
Machine-pieced, hand-quilted cotton and wool, 81 x 70¼ in.
(205.7 x 178.4 cm)

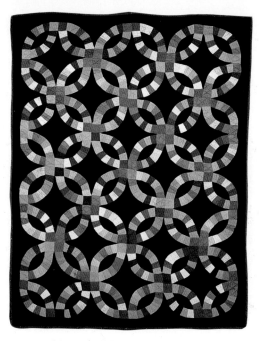

Mrs. Andy G. Byler (dates unknown)
Double Wedding Ring Quilt, Atlantic, Pennsylvania, 1920/35
Machine- and hand-pieced, hand-quilted cotton, and sateen, wool,
linen, rayon, 84 x 66½ in. (213.4 x 168.9 cm)

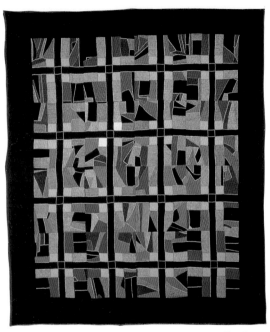

Leah Zook Hartzler (dates unknown). *Crazy Patch,* Mifflin County, Pennsylvania, Black Topper Amish, Peachey/Zook Group, 1900/20. Machine- and hand-pieced, hand-quilted wool; cotton, including sateen and polished; cotton thread, 88 x 75 in. (223.5 x 190.5 cm)

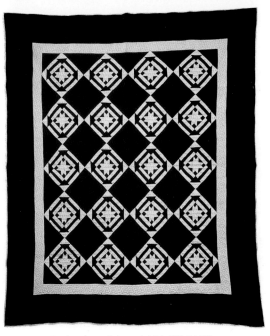

Quiltmaker unknown; initialed "L.M.Y."
Hole in the Barn Door Variation, Indiana, 1942
Machine-pieced, hand-quilted cotton, 86¼ x 72 in. (219.1 x 182.9 cm)

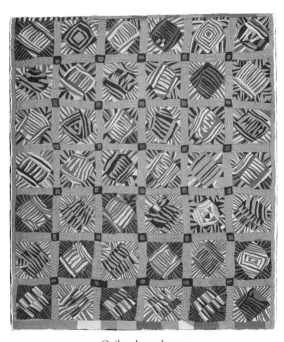

Quiltmaker unknown
String Quilt, Kentucky, 1920/30
Hand-pieced wool, muslin binding, 75¼ x 65 in.
(191.1 x 165.1 cm)

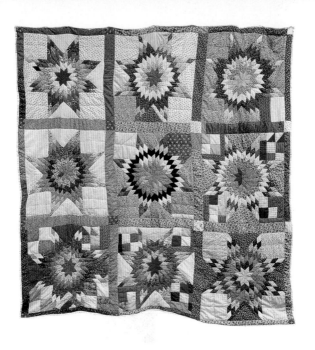

Leola Pettway (b. 1929)
Star Variation Quilt, Boykin, Alabama, 1991
Hand-pieced, hand-quilted cotton, synthetics, 78 x 81 in.
(198.1 x 205.7 cm)

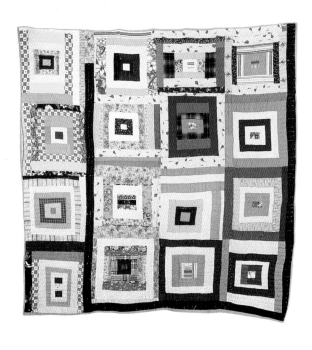

Pecolia Warner (1901–1983)
Pig Pen (Log Cabin Variation), Yazoo City, Mississippi, 1982
Hand-pieced, hand-quilted cotton (including muslin), linen,
synthetics, 79½ x 76½ in. (201.9 x 194.3 cm)

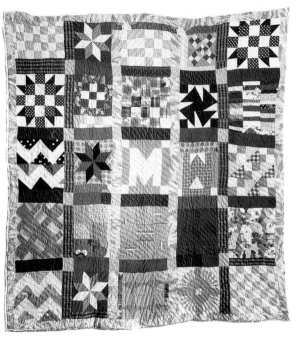

Mary Maxtion (b. 1914)
Everybody Quilt, Boligee, Alabama, 1989
Machine and hand-pieced, hand-quilted cotton (including corduroys) and synthetics, 91½ x 85 in. (232.4 x 215.9 cm)

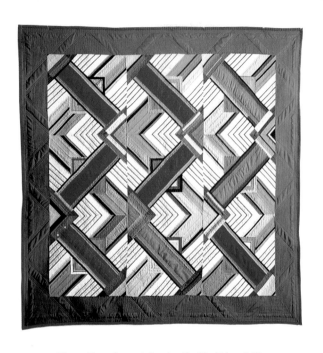

Nancy Crow (b. 1943); hand-quilted by Velma Brill,
Cambridge, Ohio. *Bittersweet XII,* Baltimore, Ohio, 1980
Hand- and machine-pieced, hand-quilted cotton polyester
broadcloth with polyester batting, 79½ x 79 in. (201.9 x 200.7 cm)

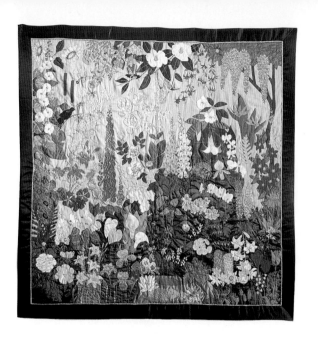

Pauline G. McCall (b. 1915)
Garden Jewels, Tampa, Florida, 1991
Satin, cotton, embroidery floss, braid, 72 x 72 in.
(182.9 x 182.9 cm)

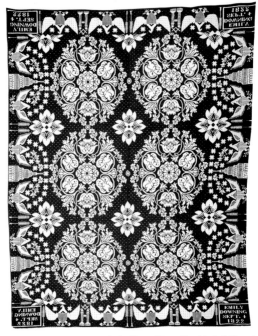

James Alexander (1772–1869/70). *Fancy-Weave Doublecloth Coverlet: Multiple Rose Medallions with Eagle and Independence Hall Border,* woven for Emily Downing, Orange County, New York, 1822. Wool and cotton, 93 x 74 in. (236.2 x 187.9 cm)

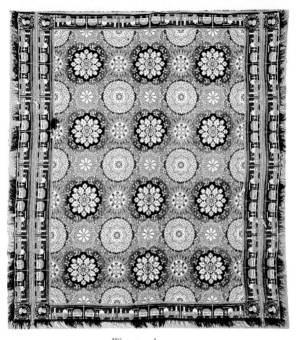

Weaver unknown
*Fancy-Weave Doublecloth Coverlet: Snowflake Medallion with
Hemfield Railroad Border,* Pennsylvania, 1850/57
Wool and cotton, 90 x 81 in. (228.6 x 205.7 cm)

337

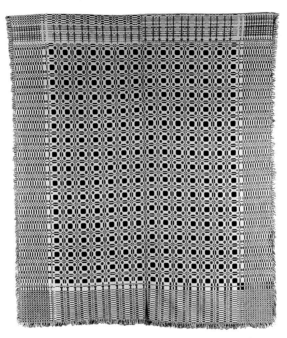

Attributed to the Mott Mill (dates unknown); woven for
Ann W. Carll. *Free Plain Double Cloth Coverlet: Blazing Star and
Snowballs,* Westbury, Long Island, New York, dated March 31, 1810
Cotton and wool, 93 x 79 in. (236.2 x 200.7 cm)

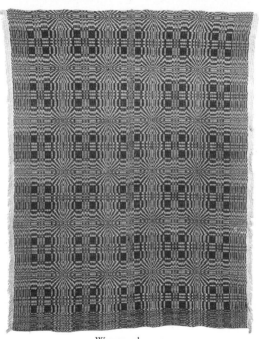

Weaver unknown
Overshot Coverlet: Sunrise, northeastern United States, 1800/40
Wool and cotton or linen, 91 x 75 in. (231.1 x 190.5 cm)

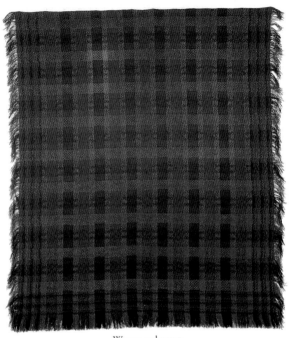

Weaver unknown
Point Twill Weave Coverlet, northeastern United States, 1840/60
Wool, 88 x 82 in. (223.5 x 208.3 cm)

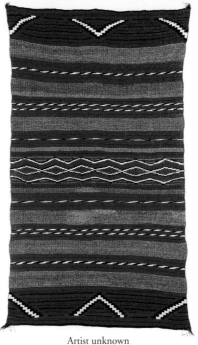

Artist unknown
Navajo Classic Child's Blanket, southwestern United States, c. 1855
Wool (Bayeta and Churro), 30 x 50 in. (76.2 x 127 cm)

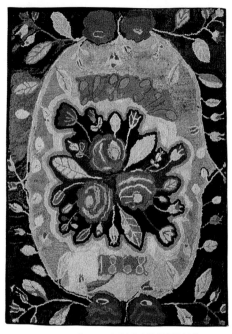

Artist unknown; initialed "M.E.H.N."
Hooked Rug: Spray of Flowers, probably New England, 1868
Wool on burlap, 46 x 32½ in. (116.8 x 82.6 cm)

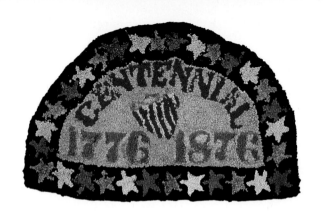

Artist unknown
Hooked Rug: "Centennial," probably New England, c. 1876
Wool on burlap, 28 x 38 in. (71.1 x 96.5 cm)

Unidentified Shaker
Crocheted Shaker Rug, Watervliet Community, New York or Maine,
1880/1900. Hand-dyed wool, woven wool cloth, ingrain carpet
remnants, 55 x 37½ in. (139.7 x 95.3 cm)

Unidentified Shaker
Braided Rug, New York State, late 19th century
Braided and knitted cotton and wool, 44 in. (111.8 cm) diameter

Artist unknown
Bicycle Hooked Rug, United States, early 20th century
Wool, burlap, cotton binding, 32½ x 46 in. (82.6 x 116.8 cm)

Artist unknown
Hooked Rug: Simple Simon, possibly Connecticut, c. 1930
Wool on burlap, 24 x 36 in. (60.9 x 91.4 cm)

Index of Donor Credits

Index of Artists and Titles

Other Tiny Folios™
in this series from Abbeville Press

1-800-ARTBOOK (in U.S. only)
Available wherever fine books are sold